MAKING ART FROM MAPS

JILL K. BERRY

ROCKPORT

© 2016 Quarto Publishing Group USA Inc.
Text © 2016 Jill K. Berry

First published in the United States of America in 2016 by
Rockport Publishers, an Imprint of
Quarto Publishing Group USA Inc.
100 Cummings Center
Suite 406-L
Beverly, Massachusetts 01915-6101
Telephone: (978) 282-9590
Fax: (978) 283-2742
QuartoKnows.com
Visit our blogs at QuartoKnows.com

10 9 8 7 6 5 4 3 2 1

ISBN: 978-1-63159-102-0

Digital edition published in 2016
eISBN: 978-1-62788-856-1

Library of Congress Cataloging-in-Publication Data

Names: Berry, Jill K., author.
Title: Making art from maps / Jill K. Berry.
Description: Beverly, Massachusetts : Quarto Publishing Group, USA, Inc.,
[2016] | Includes bibliographical references and index.
Identifiers: LCCN 2016003842 (print) | LCCN 2016006560 (ebook) | ISBN
9781631591020 (flexibound) | ISBN 9781627888561 (eISBN) | ISBN
9781627888561 ()
Subjects: LCSH: Paper work. | Paper work--Materials. | Maps.
Classification: LCC TT870 .B4674 2016 (print) | LCC TT870 (ebook) | DDC
745.54--dc23
LC record available at http://lccn.loc.gov/2016003842

Design: Samantha J. Bednarek
Cover Image: John Dilnot
Photography: Jill K. Berry, except as noted

Printed in China

DEDICATION

I dedicate this book to Metzger Maps of Seattle, which was the first cartographic wonderland I remember as a child. We regularly visited relatives in Seattle when I was a kid, and this store is right in the heart of downtown among the sites to see. The first time I walked in the door I swooned! The maps are floor to ceiling, and every kind of map and related trinket is available there. They sent me many of them in a large wonderful box to use for projects in this book.

And to my magnificent children Sydney and Sam: May you continue to wander and explore all of your possibilites.

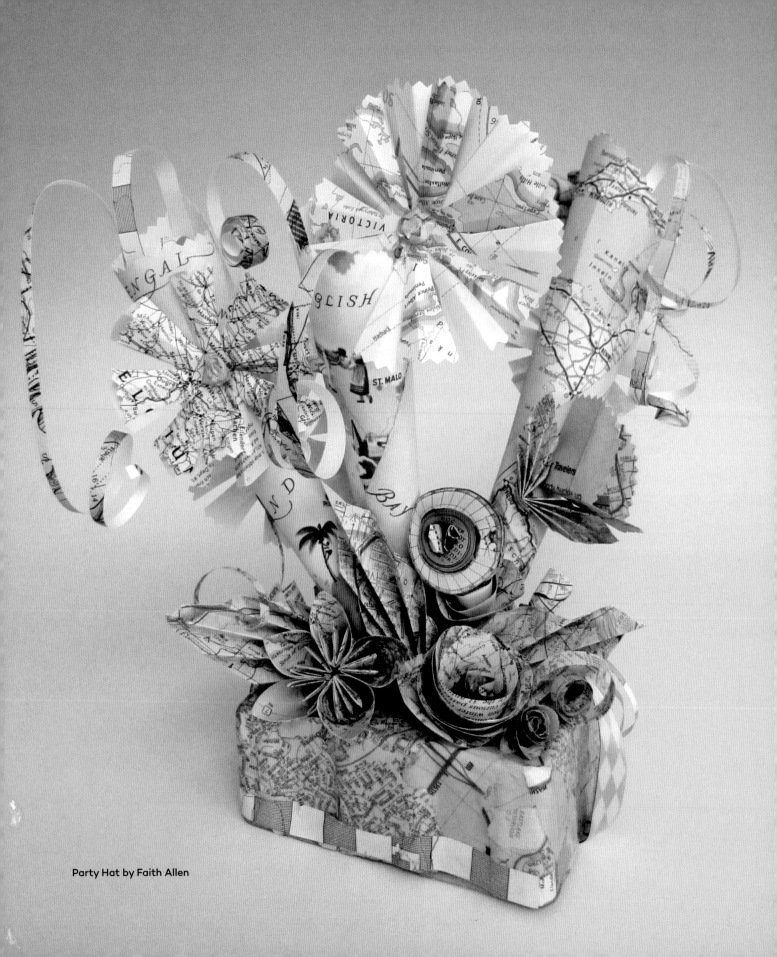

Party Hat by Faith Allen

CONTENTS

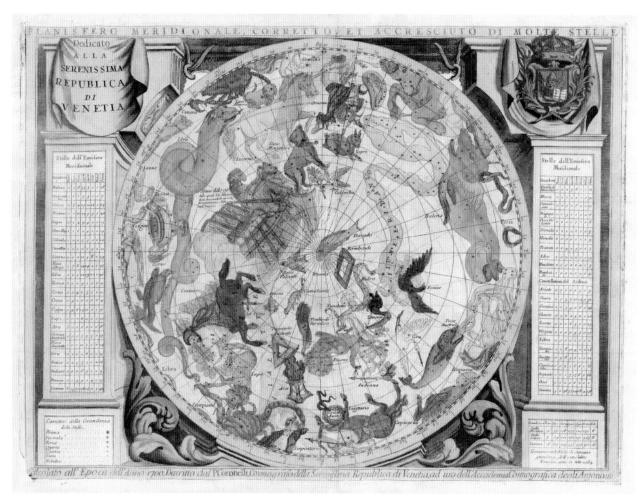

The first maps we know of are of the heavens and were painted in caves in France as early as 16,500 BCE. Celestial charts continue to be made today, but have never surpassed this Venetian masterpiece by Coronelli dating to 1700.

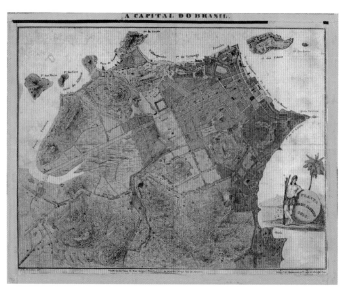

This brightly colored 1831 map from the Library of Congress appears to be a real estate pitch for a house in Brazil.

INTRODUCTION

Ask a random roomful of people to raise their hands if they love maps and the response, inevitably, will be a majority of hands in the air. For visual people this is an easy question, as it is for those with a bent for science. But why does the average person love maps?

The attraction is well documented and the answers vary from simply knowing where one is in the world to appreciating the illustrated tale a map tells.

When I ask people about their attraction to maps, it's often simply the detail that they love: the lines, precision, colors, shapes, and grid. It's the compass roses and sea monsters, the sailing ships and cartouches. Simply put, it's the visual nature of maps that attracts many of us, without regard to accuracy or usefulness.

For me, it's the story of maps themselves, the connection I feel to the mapmakers of the past who scratched planetary systems on cave walls or penned a path to the Fountain of Youth on an animal skin. The story of maps and mapmakers began thousands of years ago, and that art/science/compulsion has continued to this day.

Since the beginning, the materials of mapmaking have changed with demand and the availability of resources. They have been drawn and painted on walls, skins, papyrus, and handmade paper of all kinds. Maps have been carved in wood and on stone tablets, inscribed in clay, and, finally, produced on manufactured paper with a printing press. The printed map is what many of us have come to know as the map standard. That is about to change: electronic maps will be the standard for upcoming generations.

Many of us obsessed with maps are not ready for this change. My love for maps—the folded paper, find-your-way kind of maps—goes back to childhood. I was the map holder on family trips. I wanted to know where I was at every point along the way. The first map I kept was one my first boyfriend gave me. He worked

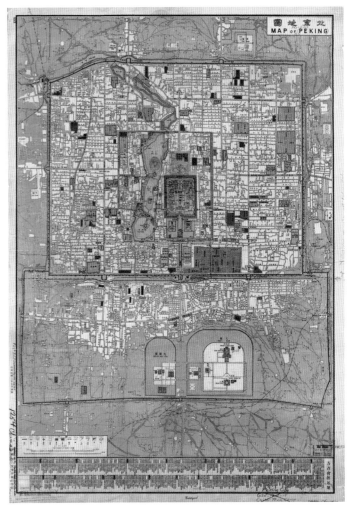

Consider the colors and flow of this 1914 map of Peking (the romanticized name for Beijing), China. It appears to be an intimate detail of something complex and organic, or the bisection of a gem.

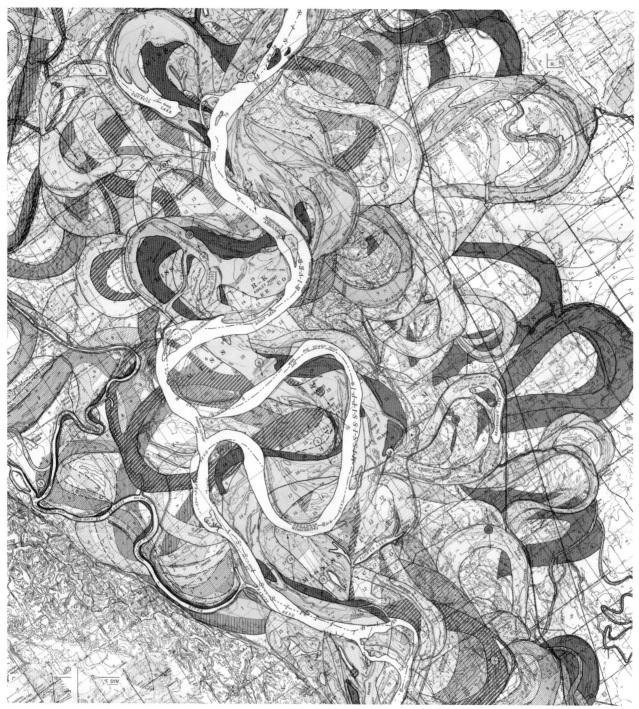

Part of a series created by the Army Corps of Engineers in 1944, this map turns the Mississippi River into an ethereal flowing dream.

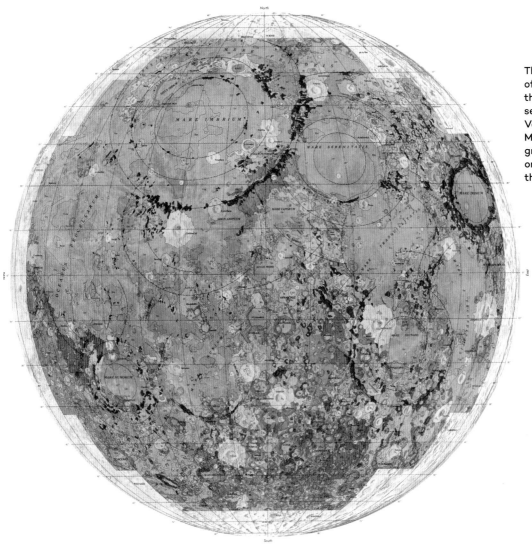

This geological map of the near side of the moon is from a series of atlases of Venus, Mars, and the Moon, created by a group of governmental organizations in the 1970s.

at McDonald's and they made maps of all their stores in California. My McDonald's map has never been used for its original purpose, but it is so kitschy and nostalgic that I keep it.

As I grew, so did my interest in cartography. I read a lot of books about maps and with research I realized that what I knew as a map was only a very small tip of the cartographic iceberg. With further study, I found maps of the skies, ocean bottoms, rivers, planets, and both real and fictitious locations. I learned that maps are often more art than science and that some of them are purposefully meant to lead the viewer astray.

Because maps have so many styles and purposes and are (still) made from paper,

they are great fodder for art making. I have a background in art, including working with books and all kinds of crafts, and combining art and maps always seemed a path worth taking to me. Lo and behold, somewhere on the journey, the path turned into a meandering map of its own, leading me to other artists, worldwide, who also work this way.

That leads me to the purpose of this book: to introduce you to those artists, to a broad scope of maps that you may not otherwise see, and to a host of inventive projects to make with those maps.

—Jill K. Berry

MATERIALS AND TOOLS

Finding maps

Turn to "Map Resources" on page 152 for a list of reliable suppliers. Thrift shops, secondhand bookstores, and yard sales may also turn up gems. Some stores that sell collector-quality maps may have worn or damaged examples that you can get for a good price. If they are super unique, scan and print them, and file the original away.

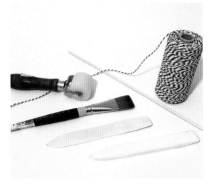

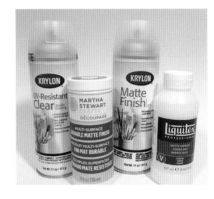

Adhesives

When working on paper projects it is best to use the least amount of adhesive possible, in order to retain the softness of the paper. If the glue you have is too wet, leave the lid off for several hours; wet adhesive can cause buckling. Here are some alternatives:

- Clear tape and double-sided tape are great for projects that will not stand up to any wetness.
- Glue dots are useful for projects with dimension.
- A glue gun is helpful for projects that have delicate parts or many parts because it allows you to work quickly.
- A glue stick works well for ephemeral projects.
- Matte gel can be used as an adhesive and as a sealer.
- Adhesive mounting sheets are great for flat projects that cannot handle moisture.
- Pastes are a good choice for lighter weight papers.
- PVA (polyvinyl acetate) is used for cardboard and heavy papers.

Cutting Tools

Always work with sharp cutting tools. Dull tools can tear a map: if it's an original, that will be a very sad thing. Have your scissors sharpened professionally, keep a fresh supply of craft knife blades handy, and sharpen hole punches by using them once on aluminum foil.

- Nonstick scissors are great for the projects in this book.
- Circle cutters take the agony out of cutting accurate circles.
- Rotary cutters are great for cutting long strips.
- A steel ruler provides a straight edge to use with cutting tools.
- An inexpensive hole punch will be fine for use on most paper and cardboard.

Other Tools

If you have these in your arsenal of tools, you're sure to use them:

- Brayers for wrinkle-free gluing
- Brushes for glue and paint
- String or lightweight yarn
- Bone folder or dull knife for creasing
- Teflon folder
- Wooden skewer for rolling beads

Surface Treatments

Varnishes will help protect and extend the life of your map art projects. A matte finish is recommended because maps generally look better without a glossy finish.

Some varieties to consider:

- UV protectant spray varnish. This is great for fragile projects that may be exposed to windows or other light sources.
- Matte spray varnish
- Matte decoupage finish in brush-on gel
- Matte professional varnish

FOUNDATIONAL BASICS

You'll refer back to this section often as you make your way through this book. Each of the small projects here shows you how to make the core elements that are used frequently in paper crafting.

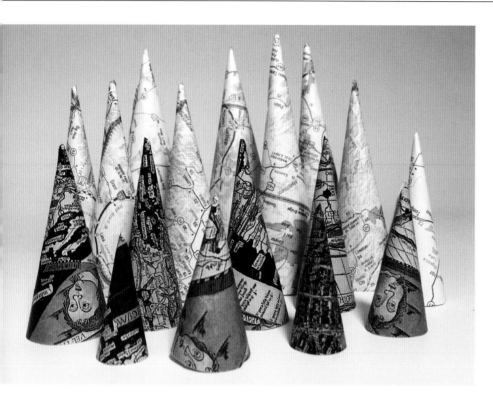

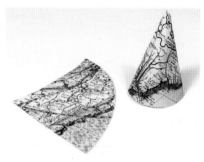

Quarter Circle Cone

Cut a circle from a map and cut the circle into quarters. Place a small amount of glue along one straight edge. Curl the piece so that the two straight edges meet. Glue the edges into place.

CONES

Make paper cones from a quarter circle of a map or from a simple rectangle. The quarter-circle cones will have the shape of a party hat; the rectangular cones are more like a horn. Both will work for embellishing wreaths, hats, ornaments, and lots of other projects.

TOOLS AND MATERIALS
- small pieces of maps
- scissors
- craft glue

Rectangular Cone

Cut a rectangular piece of map. Roll the piece so that it's narrow at one end and wide at the other. You will be able to adjust the width of the opening. Glue the seam.

FLOWERS

Be it a rose from a map of London or a daisy from a map of Tokyo, flowers made of maps are easy and irresistible. An entire arrangement of cartographic flowers would be stunning!

Twirled Rose

These roses are beautiful and they're easy to make—after the first one, at least. Practice on scrap paper before you use your best map: the petal fold requires a bit of a learning curve. If you work while the paper is moist from the matte medium, you'll find it easier to shape the rose. If the paper dries out while you're working, spritz it lightly with water. It will tear if it gets too wet, so be careful not to soak it!

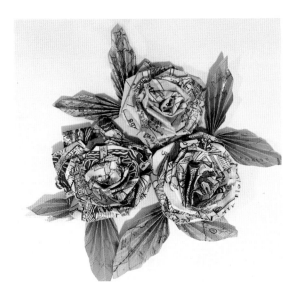

TOOLS AND MATERIALS

- strips of maps 2 x 40 inches (5 x 101.6 cm) (glue strips together to get the length)
- matte medium
- glue brush
- white craft glue
- spray bottle of water (optional)

1 Fold a long strip of map in half lengthwise.

2 Open the fold. Paint matte medium along its length. Press the two sides of the strip together again.

3 While the paper is moist, fold down a 3-inch (7.5 cm) length at one end of the strip.

4 Fold the 3-inch (7.5 cm) section in half again, along its length. The top of this section will become the center of the rose, and the lower part will be the stem.

5 With your dominant hand, hold the stem close to the top.

6 With your other hand, bend the long strip over your thumb, away from you, to make the first petal.

7 With your dominant hand, roll the rose toward you to wrap the petal into place.

8 Continue shaping the petals, bending the strip away from you with one hand and then rolling the rose toward you with the other. Be careful holding the stem so that you don't pull out the center of the rose. Push the center up again if you have pulled too hard.

9 Continue rolling the rose to the right, bending the petals outward over your thumb, until you run out of paper.

10 Glue the end of the strip to the base of the rose. Add extra glue at the center back of the rose to stabilize the petals.

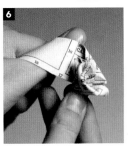

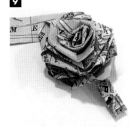

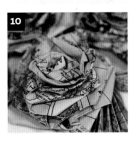

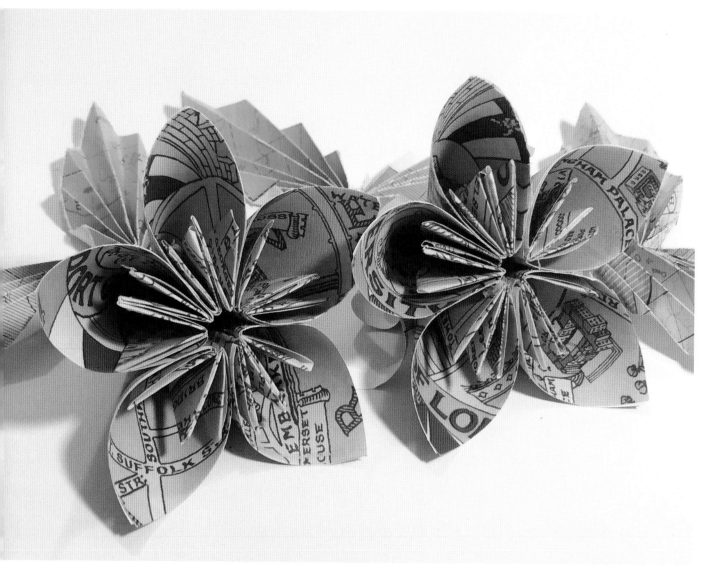

Kusudama Flower

The Japanese kusudama (薬玉; lit. medicine ball) flower is composed of multiple identical petals folded from squares of paper. Once the individual petals are formed, they are arranged and attached to make a flower shape. The leaves are made separately; see page 18.

TOOLS AND MATERIALS

- 5 square pieces of map
- scissors or paper cutter
- craft glue

1 Start with a square piece of map, the size of your choice. Place it in a diamond shape in front of you. Fold the bottom point to the top and crease the fold.

2 Fold the left and right corners up to meet at the top center. Crease the folds. The piece will form a diamond.

2

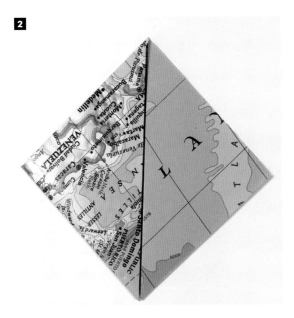

4

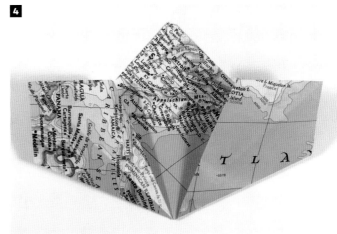

3

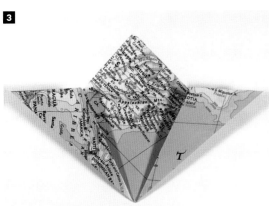

5

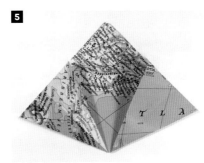

6

8

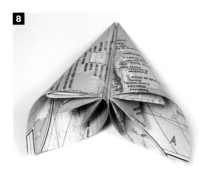

3 Fold each of the two front flaps diagonally downward. Line up the long edges of the flaps with the outer edge of the diamond so that they each form a triangle. Crease the folds.

4 Open out one of the triangles and re-flatten it along the earlier creases so that it forms a diamond shape. Repeat on the other side.

5 Fold over the top of one diamond, so that it tucks into the pocket behind it. Repeat with the second diamond. You now have two side triangles.

6 Fold each of the triangles in half to create two triangular flaps on each side.

7 Put glue on the outside of one flap. Roll the two sides toward each other so that the outer flaps meet. Hold in place until the glue sets up a bit.

8 Make five of these units and glue them together at the seam.

Stacked Petals

This is the perfect project for using up small scraps. The flowers can be stacked in as many layers as you like. The slight cup shape gives them a playfully realistic look, like a flower bending toward the sun.

TOOLS AND MATERIALS

- map scraps in contrasting colors
- scissors
- scissors with a decorative cutting edge, optional
- glue
- awl or tapestry needle
- paper fastener

1 Cut circles of various sizes from the maps. Use decorative scissors to vary the edges if you wish.

2 Fold some of the circles into quarters and cut a petal pattern along the edge. Cut the petals on the folded edges half the width of the others so that all the petals are the same width when you open the circle out again.

3 Cut one of the petals in half, from the outer edge to the center of the flower. Overlap the two halves of the petal and glue them together so that the flower cups forward slightly.

4 Stack as many flower layers as you like. Poke a hole in the center with an awl or a tapestry needle. Attach the sections with a paper fastener.

2

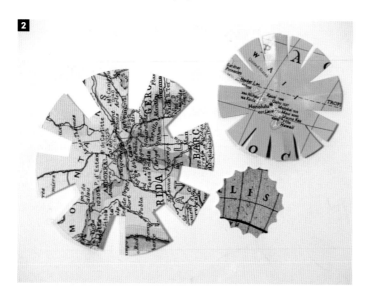

3

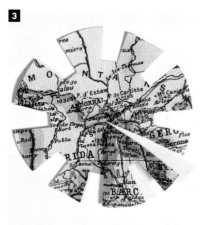

4

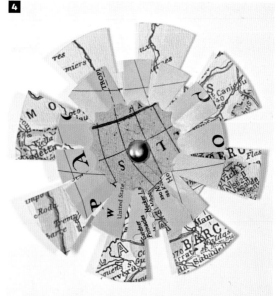

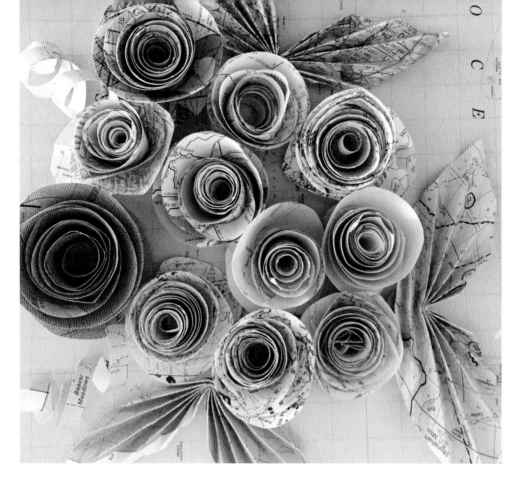

Spiral Buds

Road maps are perfect for these spiral buds because they are generally printed on both sides. Basically, this flower is a simple spiral that is wound up and glued to a base in the center. You can cut out the spiral with wavy lines or with decorative scissors—any edge treatment will work.

TOOLS AND MATERIALS

- two-sided map
- scissors
- scissors with a decorative cutting edge (optional)
- craft glue

1 Cut out a circular piece of map. Starting at the outer edge, cut the circle into a spiral, leaving a circle for the base in the center.

2 The outer end of the spiral will become the center of the flower. Make a few small folds at the outer end. Beginning at the outer end, wind the spiral toward the center.

3 Apply glue to the flower base at the center. Position the spiral on top of it.

4 Allow the bud to expand until you like the shape. Press the base around the spiral to form the outer layer of petals.

1
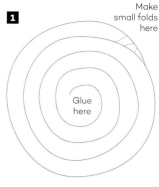
Make small folds here

Glue here

2
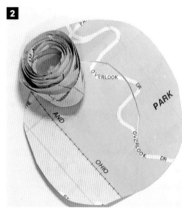

3
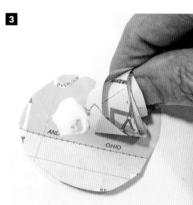

4
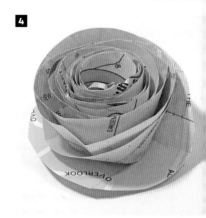

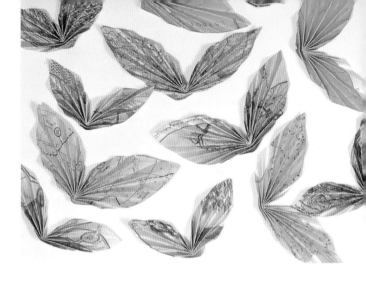

Tendrils

These small spirals add a bit of botanical detail and a sense of whimsy to any map project.

TOOLS AND MATERIALS
- map scraps
- scissors
- pencil

1 Cut a thin strip of map. Wind it around a pencil, very tightly.

2 Slip the tendril off the pencil and pull one end to shape it.

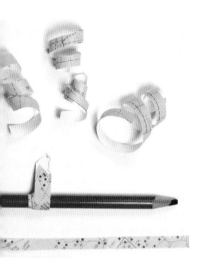

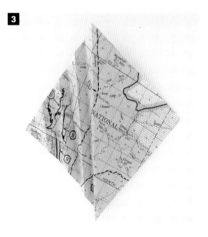

Leaves

The shape and sharp geometry of these leaves contrast nicely with the soft shapes of paper flowers. Maps, with their winding rivers and roads, are the perfect papers with which to make leaves.

TOOLS AND MATERIALS
- green toned maps
- scissors

1 Cut the maps into squares of varying sizes.

2 Fold each square in half diagonally. Crease the fold and open again.

3 Accordion-fold each side of the square toward the center fold.

4 Condense and stack the folds.

5 Pinch the stack in the center and fold the ends upward. Fan out the folds to make the leaves fuller.

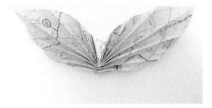

TAPES

These tapes can be used for edging, framing journal entries, or anywhere that washi (Japanese paper tape) and ribbons might be used.

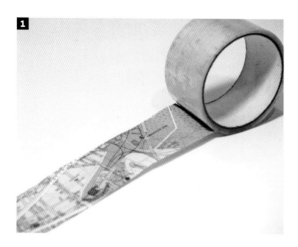

Packing Tape

These map strips are sturdy and pliable and can even be machine stitched.

TOOLS AND MATERIALS

- clear packing tape
- map strips
- scissors
- spoon or bone folder

1 Apply packing tape to the tops of the map strips.

2 Trim the map to the width of the tape.

3 Rub the tape with the back of a spoon or a bone folder to board.

4 Drop the tape into warm water and pull it out. Let it set for a while.

5 Gently rub off the map paper. The first thin layer of the map will stay on the tape.

6 Let it dry completely before using for edging or sewing projects.

Paper Tape

This is an easy way to apply thin strips of maps to any project. No glue is used. Use the tapes in journals or anywhere you would use a decorative edging.

TOOLS AND MATERIALS

- maps or map scraps
- double-sided tape
- wax paper (optional)
- scissors

1 Apply double-sided tape to the back side of a map. Cut to the width of the tape. Pull off the backing and apply the tape where desired.

2 Alternatively, if you are using double-sided tape that does not have a pull-off backing, apply the tape to wax paper first and layer the map paper on top. Trim to the width of the tape. Pull off the wax paper when you are ready to use the tape.

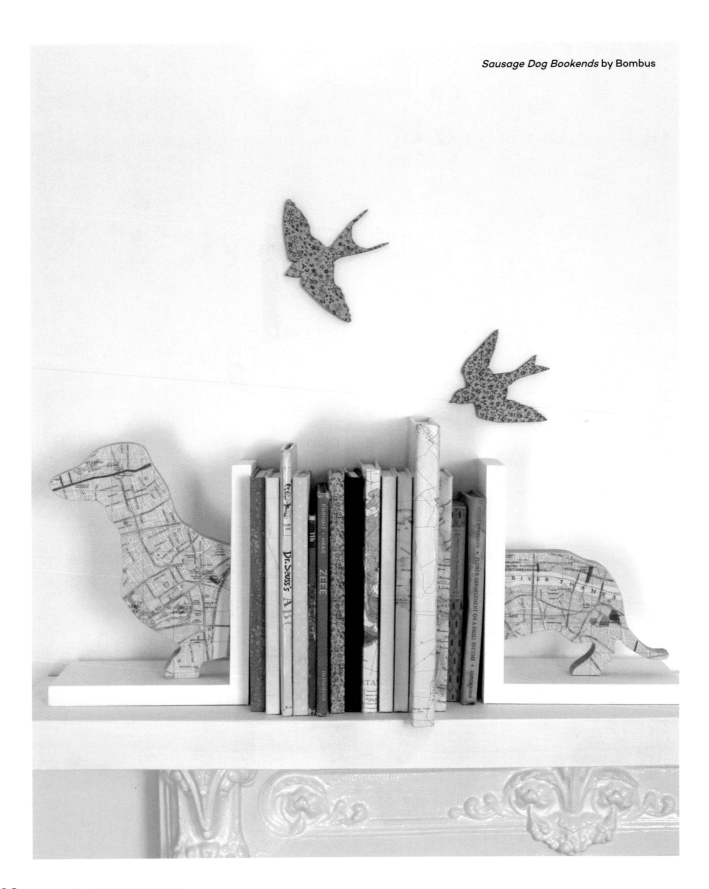

Sausage Dog Bookends by Bombus

DÉCOR

What room wouldn't benefit from a little map magic? Maps provide a talking point. They reveal a subtle something about you—your interest in outer space, your travels in Zanzibar, or your great-grandpa's river trip down the Mississippi. Even small bits and pieces of maps grab the eye and spark the imagination, reminding you of journeys past and those yet to come. What's more, maps look just as at home in modern settings as they do in cozy dens full of antiques. Whether in formal living rooms or mudrooms, bedrooms or bathrooms, their colors, textures, and destinations add warmth with a story to tell. This chapter is full of ways you can use them.

MINI DIORAMA

These decorative pieces use a bit of map as a background and small treasures to tell a story or create a tiny world. I used figures from a model railroad in mine, but the possibilities are endless. You can make your treasures appear to float inside the shadow box by attaching head pins to the back of them. Head pins can be found wherever jewelry-making supplies are sold. Alternatively, you can use a clear bead for the purpose.

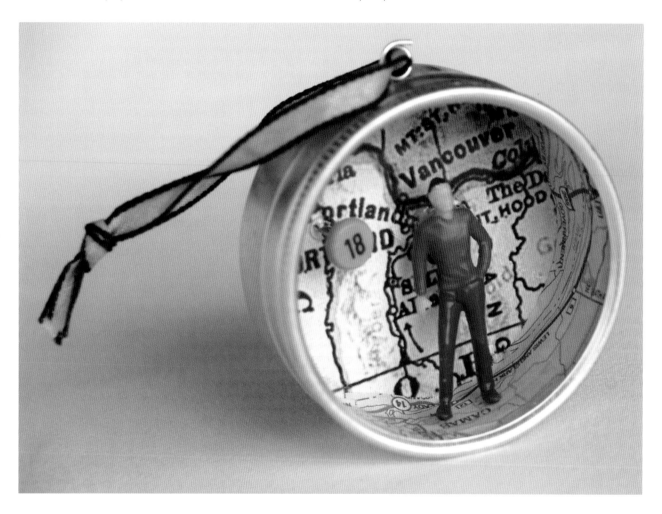

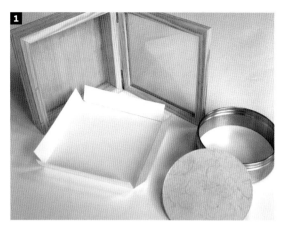

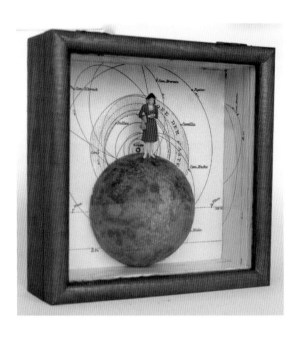

1 Measure the interior dimensions of the shadow box: base and sides all in one for a rectangular box, base and sides separately for a round box. Transfer the measurements to a piece of scrap paper to create a pattern. Cut out the pattern and make sure it fits inside the box. Adjust as needed. Trace the pattern onto a piece of map. Cut out the map.

2 If desired, paint the shadow box and allow it to dry. Brush matte medium onto the back of the prepared piece of map. Glue the map in place inside the shadow box. Press it down gently, using paper toweling so as not to tear the map.

TOOLS AND MATERIALS

- shadow box, watch case, or other dimensional container with a glass front.
- ruler
- pencil
- scrap paper
- scissors or circle cutter
- map
- paint (optional)
- paint brush (optional)
- matte medium
- brush for medium
- paper toweling or soft cloth
- glue gun
- headpins or clear beads (optional)
- needle-nosed pliers
- cutting mat
- mixed media stuff to put inside

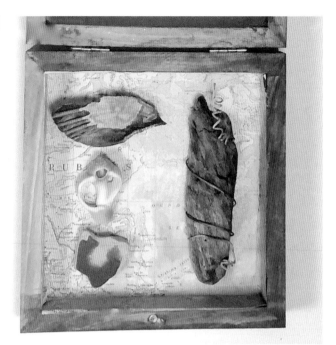

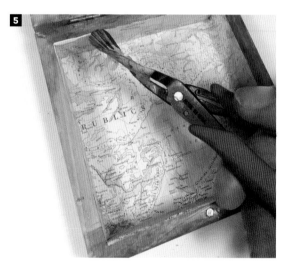

3 Arrange your treasures in the box. Move them around and try them in different spots until you find a composition that pleases you. Attach the pieces with a glue gun.

4 To make one of your treasures "float" inside the shadow box, use a glue gun to attach a head pin or bead to the back of it. Allow the glue to set up.

5 Trim the head pin or bead to the desired length with pliers. Add a dab of glue to the trimmed end while holding the piece with pliers. Quickly arrange the piece in the shadow box and hold in place while the glue sets up.

6 Keep adding the treasures. The depth of the head pin or bead will determine how far the treasure stands out from the background.

CARTOGRAPHIC COASTERS

These are quick and easy enough to make as gifts. Match the maps to the giftee's hometown, favorite journey, or dream vacation.

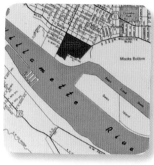
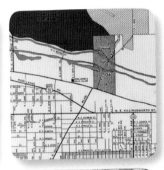
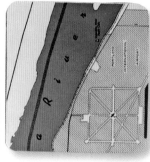

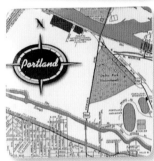

TOOLS AND MATERIALS

- 9 x 13 ½ inch (23 x 33 cm) map
- 9 x 13 ½ inch (23 x 33 cm) heavy paper
- water resistant glue
- books or flat heavy objects for pressing
- steel ruler
- craft knife
- 4 x 24–inch long (10 x 61 cm) thin hobby wood
- thin cork 9 x 13½ inches (23 x 33 cm) (sheet cork is available in craft stores)
- #200 sandpaper
- waterproof coating
- paintbrush for coating

1 Laminate the map to the heavy paper with the adhesive and press under weights until dry. Cut into 4 ½-inch (11.4 cm) squares.

2 Use a craft knife and steel ruler to cut the wood into six 4-inch (10 cm) squares. Cut the cork into six 4-inch (10 cm) squares. Trim the corners, if desired. Glue the cork squares to the wood squares.

3 Place the squares cork-side down. Glue the laminated maps to the wood, leaving a slight edge on all four sides.

4 Place weights on each of the coasters and allow the glue to dry thoroughly, then trim.

5 Lightly sand the edges. Sand from the top down to avoid ripping the paper.

6 Coat the top and sides with waterproof coating. Let dry completely before using.

WOVEN BASKET

Repurpose maps from your travels to weave a practical, attractive basket full of memories of trips taken and experiences along the way. You begin by weaving a flat base and then upturn the strips (called stakes or weavers) to make the sides in bias plaiting. You'll be surprised at how sturdy your paper basket will be.

Project and photos by guest artist Jane Patrick

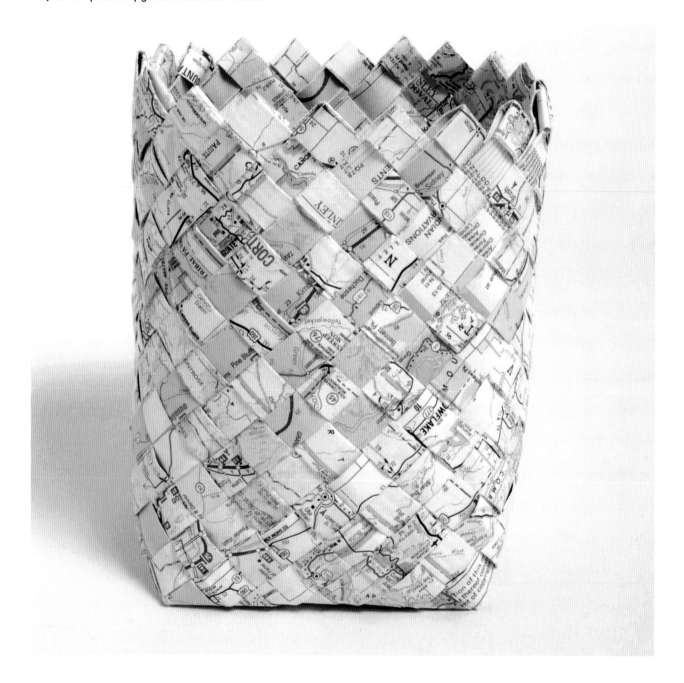

TOOLS AND MATERIALS

- 2 or 3 large road maps
- scissors
- cutting mat
- metal ruler
- rotary cutter
- contrasting string or thread
- 6 spring-type clothespins
- awl or tapestry needle (optional)
- small tweezers (optional)
- white glue and paint brush (optional)

1 Prepare the weavers. Select one of the maps. Cut off the margins or any parts of the map that you don't want to use. Lay the map vertically on the cutting mat. With the metal ruler and rotary cutter, cut 20 weavers 2 inches (5 cm) wide and 24 inches (61 cm) long. (The longer your strips, the larger your basket can be).

2 Fold each strip in half lengthwise. Then fold the edges to the center, and finally, fold these edges together, creasing tightly. The

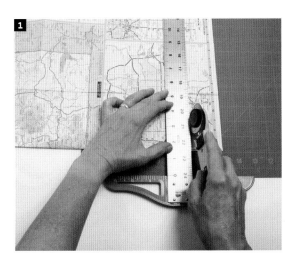

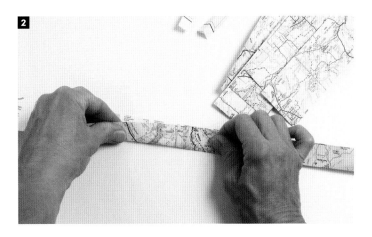

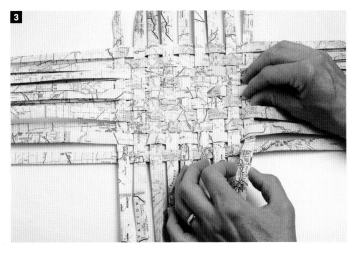

more uniform and crisp you make the strips, the better your basket will be. Repeat for all 20 weavers.

3 Weave the base. Line up 10 weavers evenly, with the open folds of the weavers facing the center of the basket. Starting at the center, weave the second set of 10 weavers, over, under, over, under for a square base. When all the weavers are woven, snug them up, making sure they are centered and form a square.

4 Mark the edges of the base by twining with string. Measure a length of lightweight string 10 times (about 2 ½ yards, or 2 m) the circumference of your base.

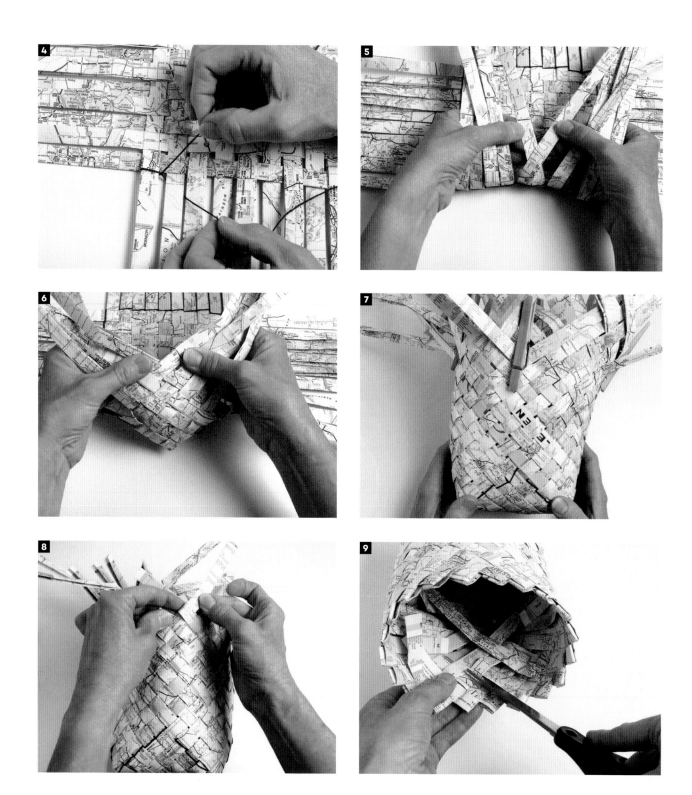

Fold the string in half and position it around a weaver so that one side of the folded string is underneath the weaver and the other is on top. To twine, simply reverse the top and bottom string positions, drawing them over and under the next weaver. Repeat, going all the way around the square base. When you reach the point where you started, tie the ends together.

5 Now you're ready to weave the sides, one side at a time. Divide the weavers on one side of the basket in half. Beginning with the center weavers, cross them at the base and then weave them out toward the edge. Weave the remaining weavers on that side of the basket in the same manner. An awl and tweezers can help get the weavers through tight spaces.

6 Tighten the weavers by pulling out the slack. The weaving will poke out where the weavers cross. You'll now have woven a diamond. Secure this side with a clothespin. Repeat for the other three sides.

7 Join the diamonds by weaving them together. Continue weaving as long as you'd like your basket to be tall or until you run out of weaving material. (You'll notice that if you follow one weaver, it travels from one side of the basket to the other.)

8 Finish the edge. Working in pairs, fold one weaver over the other and down into the weaving on the inside of the basket. Repeat for the other weaver in the pair. Do likewise with all the weavers.

9 If needed, tighten the weave of the basket by pulling the weavers from the bottom of the basket to the top. Take out the extra length by pulling on the weaver on the inside of the basket. Keep tightening until all the weavers are snug. Check the top edge to see that it's even. Trim the ends on the inside.

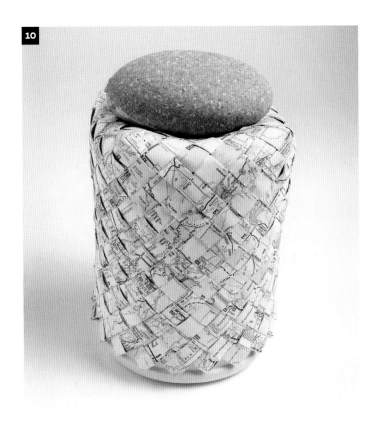

10

10 For a flat, sturdy base, place the basket over a container. Weight the bottom with something heavy like a rock for several hours. Remove the twining string and crease the edges of the base so that the basket sits flat. To give the basket extra stiffness, dilute white craft glue slightly with water and paint the basket inside and out.

Jane Patrick is creative director for loom and spinning wheel manufacturer Schacht Spindle Co. She is the author of four books on weaving, including her popular book, *The Weaver's Idea Book*. Jane lives in Boulder, Colorado.

GARLANDS

Here are three kinds of map-themed paper garlands: origami crane eggs, paper fans, and stacked disks. They're fun projects to do with a group, or with kids, because they are so easy to make and festive to hang for a party.

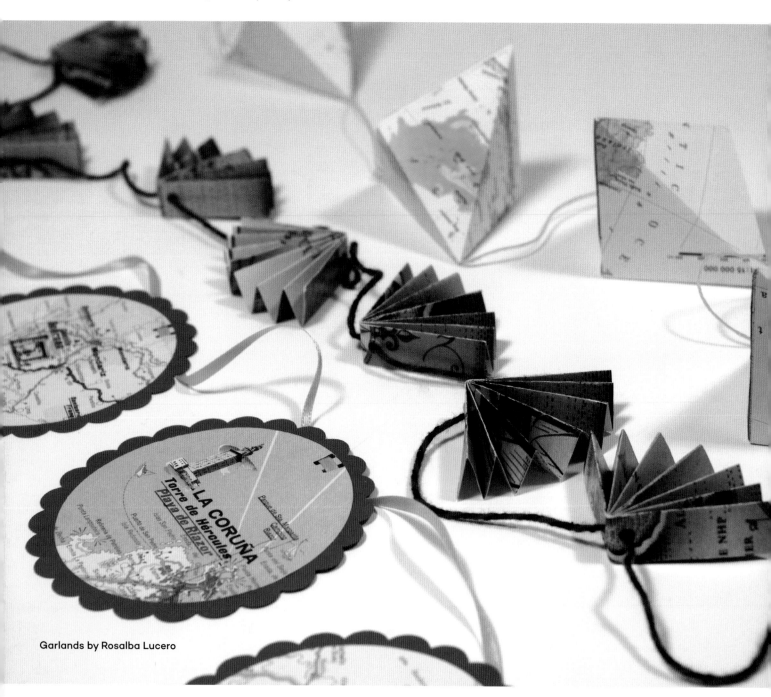

Garlands by Rosalba Lucero

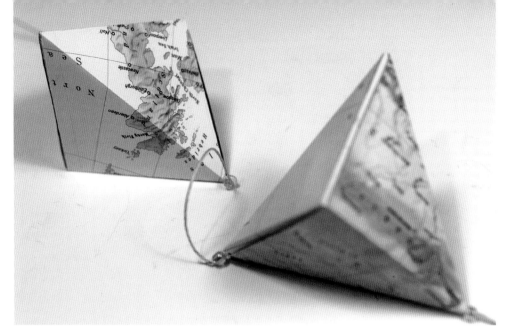

Crane Eggs

These simple paper eggs are "rolled" forms made from leftover strips of one-sided maps, and they make lovely ornamental garlands.

TOOLS AND MATERIALS

- scissors
- 2 x 16–inch (5 x 40.5 cm) map strips (as many as desired)
- string
- craft glue
- small bead with a hole large enough for the string

1 Accordion-fold one strip of map. Fold the last panel diagonally.

2 Continue to fold and stack diagonally along the length of the strip.

3 Open the strip out again and begin to roll it loosely from one end, so that the diagonal panels form a hollow shape with six sides.

4 Continue, letting the folds in the paper guide you. They will wrap around the shape over and over.

5 When you get to the last two panels, fold one in on the other. Lay the string along the inside edge. Glue the string in place.

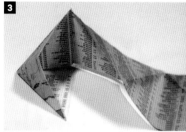

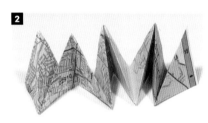

6 String a bead on either side of the shape. Make a small knot next to the bead to keep it from sliding.

7 Repeat steps 1 through 6 until you have the garland length you desire.

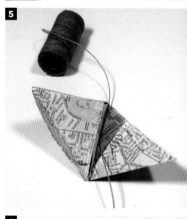

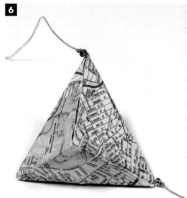

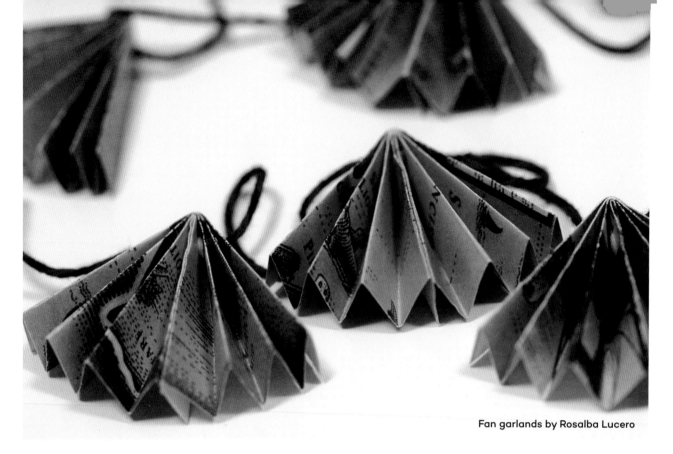

Fan garlands by Rosalba Lucero

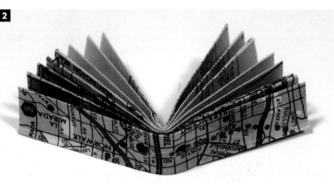

Paper Fans

Fans bring to mind hot summer days and Spanish dancers. They are easy to make to decorate your yacht, tree house, beach hut, or a festive afternoon tea.

TOOLS AND MATERIALS

- scissors
- 3 x 4–inch (7.5 x 10 cm) map scraps (as many as desired)
- small-hole paper punch
- craft glue
- string

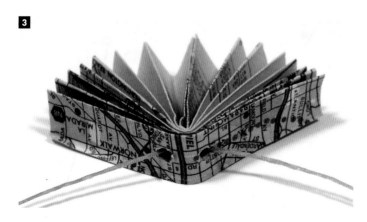

1 Accordion-fold the map rectangle on the short side. Fold the stack in half.

2 Punch a small hole on either side of the center fold.

3 Glue the center panels together. Thread the string through holes at the top.

4 Repeat steps 1 through 3 until you have the garland length you desire.

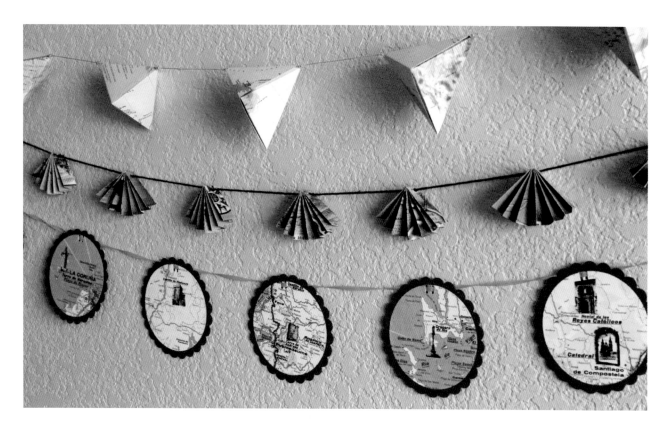

Stacked Disks

Commemorate a trip by using one map in combination with a complementary color to make a bold, graphic garland.

TOOLS AND MATERIALS

- scissors
- circle cutter
- maps
- cover-weight paper
- decorative-edge scissors
- glue
- craft knife
- ribbon

1 Use the scissors or circle cutter to cut out small circles from maps.

2 Cut out circles from the cover-weight paper larger than the map circles.

3 Use the decorative-edge scissors to trim the edge of the cover-weight paper circles.

4 Center and glue the maps onto the cover-weight paper circles.

5 With the craft knife, cut two small parallel slits at the top of the disk. The slits should be the width of the ribbon you are using.

6 String the disks onto the ribbon.

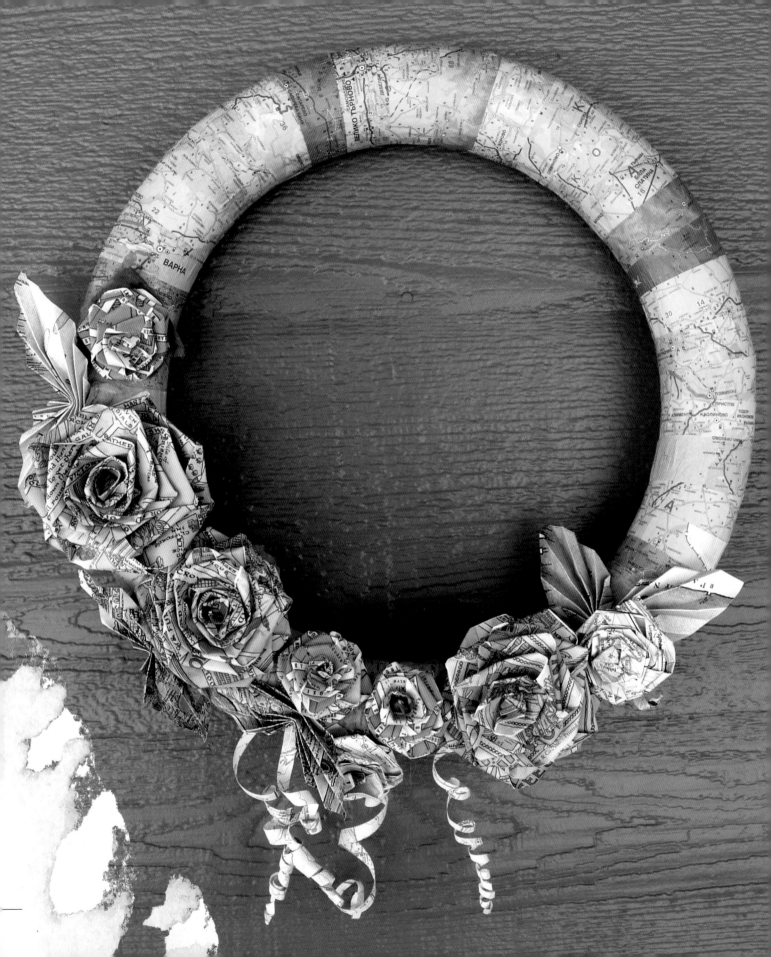

WREATHS

Wreaths have been used since ancient times as headdresses and crowns, household ornaments, and ceremonial offerings: they have been made of plants, flowers, precious metals, wheels, and fruit. With their long tradition in so many cultures, wreaths offers beauty and history, especially when made of maps.

Wrapped Floral Wreath

You can adapt this wreath to suit any setting. Choose the maps to match your décor or friend's favorite colors. Make it from an out-of-date atlas. Cover the wreath with flowers, or take a minimalist approach and use only a few. Add ribbon or paper tendrils as you like.

TOOLS AND MATERIALS

- 12-inch (30.5 cm) circular foam wreath form for base (or size of your choice)
- scissors or paper cutter
- maps
- decoupage glue or white glue (I used Mod Podge)
- brush for adhesive
- glue gun for making the flowers

1 Select a map to use for wrapping the foam form. Cut the map into strips about 1 inch (2.5 cm) wide—no wider or they will wrinkle when you wrap them. The strips should be just long enough to wrap around the form once with a small amount of overlap in the back.

2 Brush the glue onto the wreath form, covering the area where the strip will lie. Wrap each strip individually, overlapping the strip next to it just slightly. Continue brushing on glue and wrapping strips of map until the entire form is covered.

3 Make a selection of flowers and leaves according to the instructions in "Flowers" on page 13. I made eight roses for this wreath, but you can mix and match as many different flower types as you like in a variety of sizes.

4 Arrange the flowers on the top surface of the wreath until you find a composition that you like. Use the glue gun to attach the flowers and leaves. If you like, make paper curls by wrapping strips of map around a pencil, to add as flower tendrils.

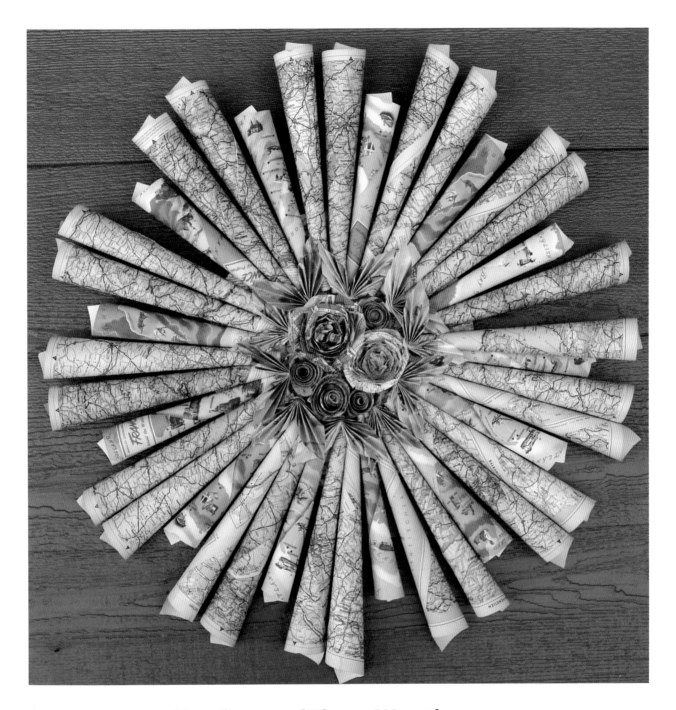

Map Cone and Flower Wreath

I used pages from an outdated atlas to make the cones for this wreath. The consistent size of the pages makes rolling the cones easy. If you don't have an old atlas handy, start by cutting maps to a consistent size (11 x 14 inches [28 x 35.5 cm] works well) or use a mix of maps and other interesting papers for variety.

TOOLS AND MATERIALS

- atlas pages
- scissors or craft knife
- contrasting map pages
- white glue
- brush for gluing
- 12-inch (30.5 cm) sheet of cardboard
- pot lid or dinner plate
- pencil
- hole punch
- 12-inch (33.5 cm) length of narrow ribbon or cord to use as a hanger
- small selection of map flowers and leaves (page 13)
- glue gun

1 Carefully remove the pages from the atlas.

2 Follow the directions in "Foundational Basics," page 12, for making the cones. If you like, combine the atlas cones with others made from contrasting maps and papers. Vary the lengths and colors of the cones. I used 13 small cones and 26 longer ones for this wreath.

3 Use a pot lid or dinner plate to trace a circle onto the sheet of cardboard. Cut out the circle with scissors or a craft knife. (Alternatively, use the precut circular cardboard from a box of frozen pizza.)

4 Brush a light coat of glue on the cardboard circle and cover it with a piece of map, folding the raw edges to the back. Punch two holes at the top of the circle and string the ribbon through to hang the wreath later.

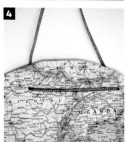

5 Arrange the cones symmetrically around the cardboard circle with the narrow ends pointed toward the center. Adjust the spacing of the cones before you begin gluing.

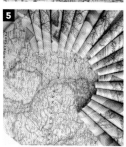

6 Compose the arrangement of flowers and leaves in the center of the wreath.

7 Use the glue gun to attach the cones and flowers for a strong and instant bond. Hang the wreath.

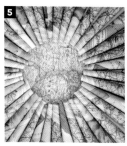

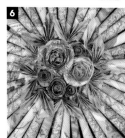

KUSUDAMA

Any number of projects can be made from kusudama flowers,
including our centerpiece and hanging ornament.

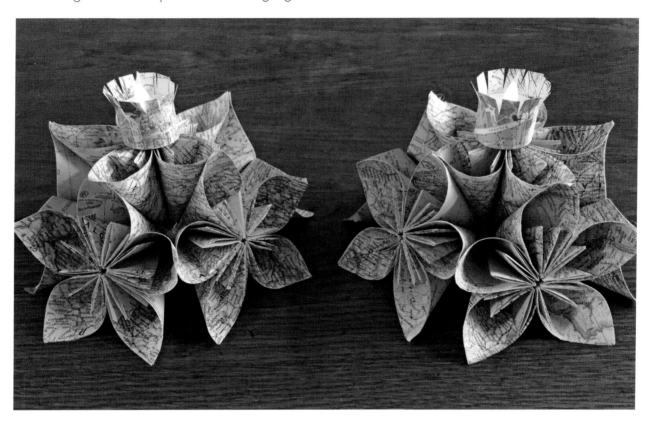

Kusudama Centerpiece

The star shape of these origami flowers allows them to sit firmly on a tabletop and
cluster into a centerpiece. Follow the steps in "Foundational Basics," page 14, to make
the flowers. You'll need six flowers for a single centerpiece, twelve for a pair.

TOOLS AND MATERIALS

(for a single centerpiece)

- thirty 4-inch (10 cm) squares
 of maps
- scissors
- glue
- map scraps
- 2 small LED lights

1 Prepare six kusudama flowers (page 14)
from the map squares.

2 On your work surface arrange five of the
flowers in a circle with the points facing
inward. Glue the flowers together individually at
the tips. Set the last flower in the center, facing
upward. Glue it in place.

3 Turn the flower arrangement over and glue
the points together on the back.

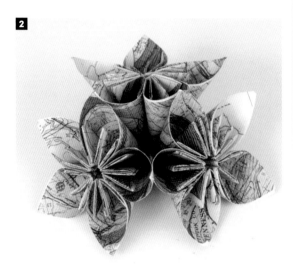

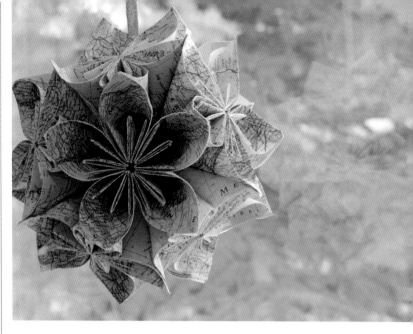

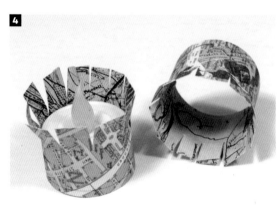

4 From the scraps, cut a strip of map to go around the LED light. The strip should be long enough to overlap slightly, and just taller than the height of the candle tip. Wrap the strip around the light and glue the overlap. Make small cuts to the top edge, and fold back gently to shape.

5 Set the light on the flat surface of the top flower and enjoy!

Kusudama Globe Ornament

Wouldn't this make the perfect decoration for a bon voyage, welcome home, or honeymoon party? It is made from two kusudama centerpieces, attached back to back. The one shown is large, made to hang from the ceiling. You could also make mini globes to hang from a tree.

TOOLS AND MATERIALS

- sixty 4-inch (10 cm) squares of maps
- scissors
- glue
- ribbon

1 Make two centerpieces, following the directions for the Kusudama Centerpiece, steps 1 through 3.

2 Cut a piece of ribbon long enough to hang the globe from the ceiling. Glue one end of the ribbon to the back of one of the centerpieces. Glue the centerpieces together, back-to-back. Allow the glue to dry.

DÉCOR GALLERY

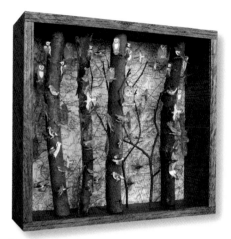

Over the Severn

John Dilnot

photos courtesy of the artist

The writer Belen Gomez, who reviewed Dilnot's work, says, "These beguiling diagrams are used by John to create vignettes in which something more elemental and dangerous is happening. Across these maps flocks of tiny, vulnerable birds huddle together to journey over the vastness of the earth. We are reminded of the miracle of migration, which these innocents are compelled to repeat again and again."

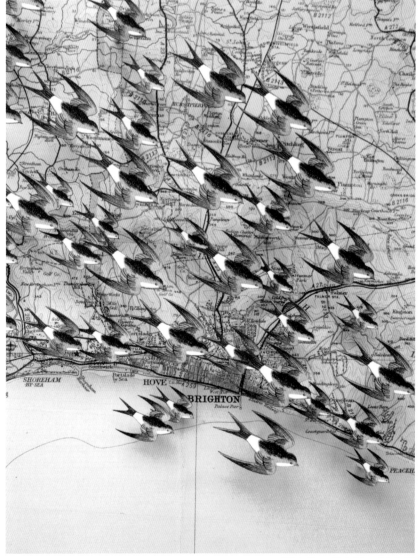

High Over Brighton (detail)

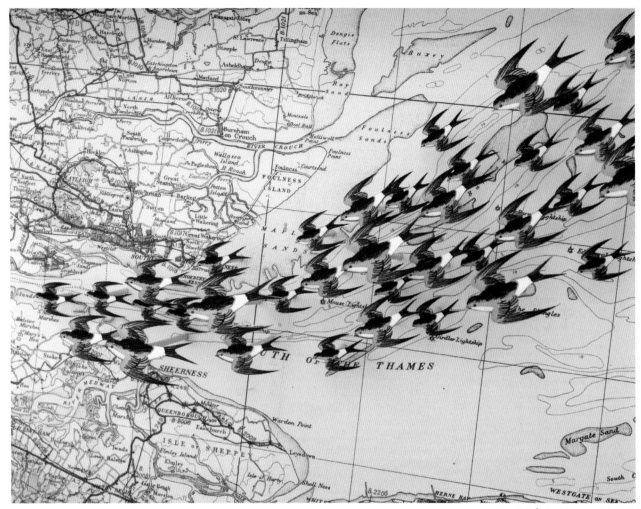

Mouth of the Thames (detail)

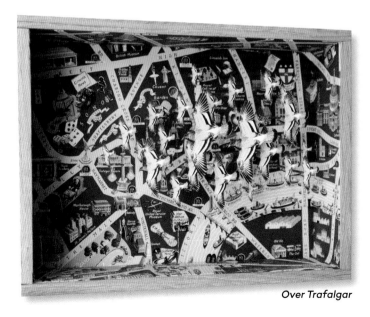

Over Trafalgar

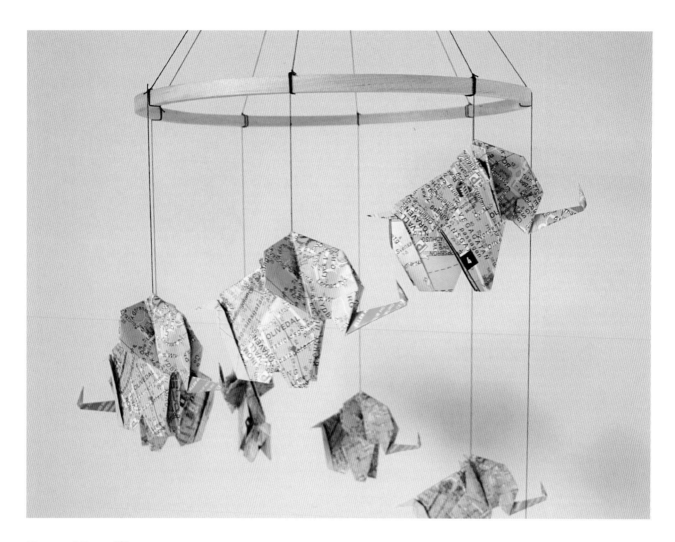

Ram Hardikar

photo courtesy of the artist

From her home in Gothenburg, Sweden, Ram
Hardikar says: "I am an IT professional and an
origami enthusiast. It all started during my
school days when one of my cousins taught me
to make a crane. Since then I have been folding
paper and even today I take every opportunity
to make something interesting for myself and
my kids. The idea of folding paper and making
something out of it is just fascinating and gives
me immense pleasure, which keeps me going."

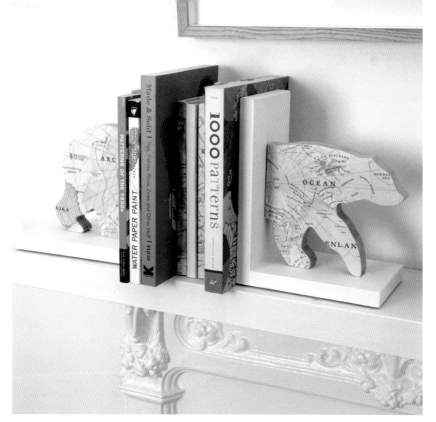

Polar Bear Bookends

Bombus

photos courtesy of the artist

Bombus was formed in 2003 in the UK by Amelia Coward. The Bombus ethos is about making something from nothing. Their signature material is the vintage map. "Fewer and fewer people are using the old fold-out maps or atlases anymore," says Coward. "We rely instead on satellite navigation and GPS, so paper maps are becoming obsolete for navigation. But people still love looking at them and, of course, locations can hold such special memories. So, we take old maps and pages from discarded atlases and turn them into pieces of heartfelt and bespoke art."

Patchwork London

Patchwork World Two

Penny Arrowood

photos courtesy of the artist

"Joseph Cornell is one of the artists whose work has always interested me," North Carolina–based artist Penny Arrowood says about her assemblage *Ode to Cornell*. "While this piece tells much of his story, it is also an overview of my own family. In the upper right corner, the three silhouetted birds represent our children—all grown and charting their own paths. The blocks are constructed of stacked cardboard squares, covered in wind direction maps—each bird is die cut from the geographical region in which it currently resides."

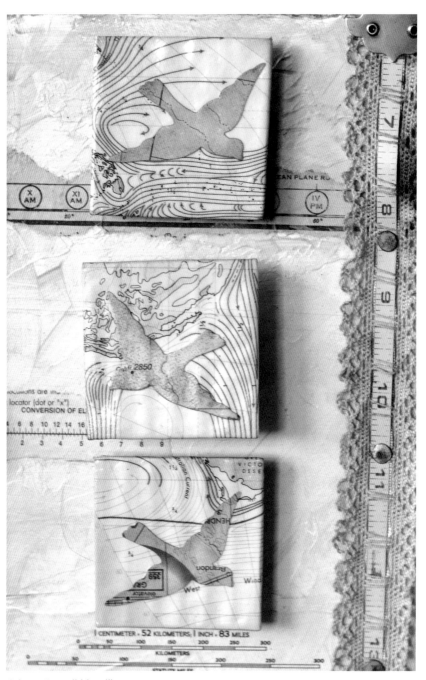

Ode to Cornell

Ode to Cornell (detail)

Concarta

photos courtesy of the artist

Los Angeles–based Concarta designs custom wedding cake toppers made from map paper. Some represent the places where the bride and groom grew up. One of them was for a bicoastal couple. "The bride and groom typically tell me what areas of the cities are special to them," says Gwen Barba, who started Concarta in 2010. "I try to be clever about using certain parts of the map in key places—City Hall on the groom's bow tie, flower centers made from LA's freeways, or two sentimental streets intersecting on a bouquet ribbon."

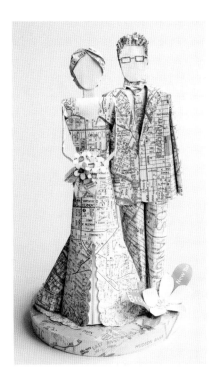

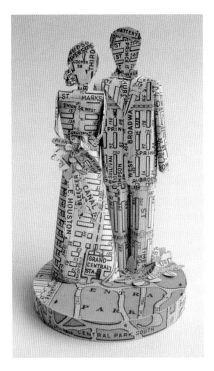

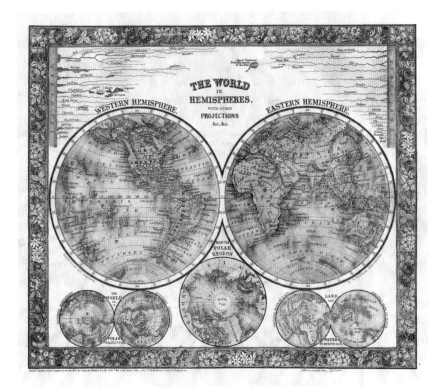

Lisa Middleton

photo courtesy of the artist

Lisa Middleton grew up along the Mississippi River, exploring every nook and cranny—both on the water and off—with her family. Her special talent is color, blending, and a sensitivity to the joys that maps hold for many of us. Middleton both restores and reinvents historic maps with paint. This example is an 1864 painted map of the world in hemispheres featuring the lengths of the rivers of the world by S. Augustus Mitchell.

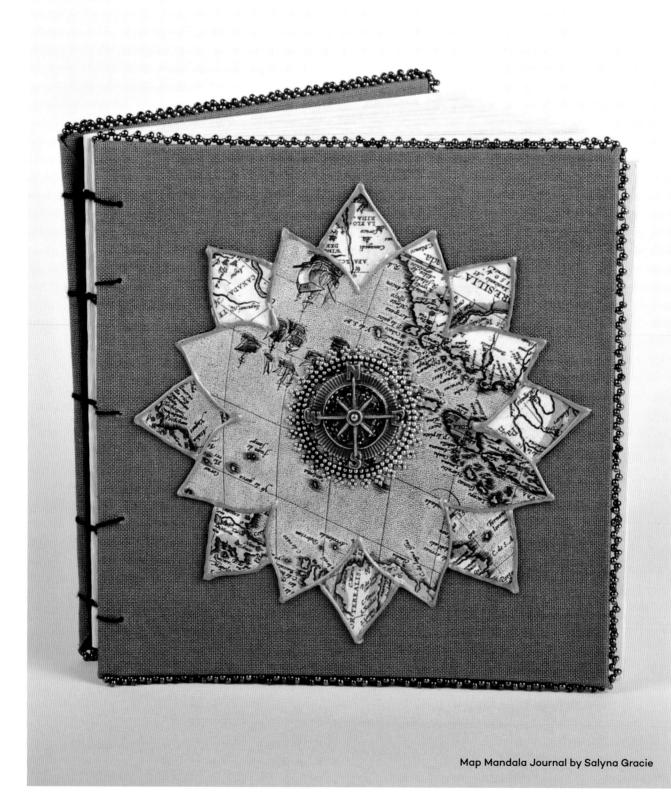

Map Mandala Journal by Salyna Gracie

BOOKS, JOURNALS, AND BOXES

Maps and books go hand in hand, both when the books already have maps inside them—as in atlases and history books—and when we add them to our journals and handmade books. And who wouldn't want to receive a small treasure in a box made of maps? Map books, journals, and boxes make lovely, personalized gifts for anyone with a love of travel. Many of us come home from our vacations with stacks of maps and these are some of the ways to use them.

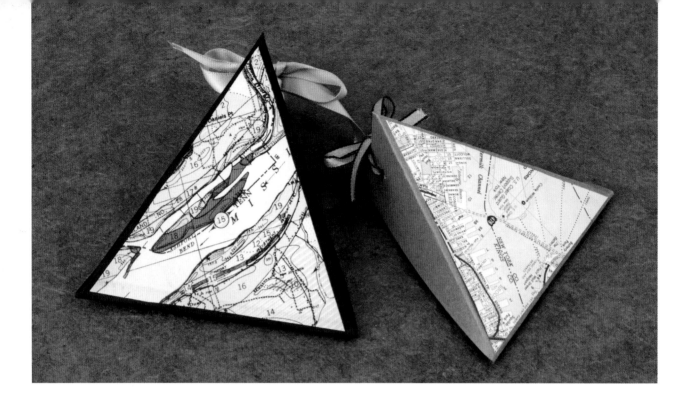

TRIANGLE BOX

This charming little box takes almost no time to make. It'll make you look very arty and clever when you gift it to someone.

TOOLS AND MATERIALS

- ruler
- pencil
- scissors
- rectangular piece of paper (width = 2x height)
- hole punch
- 6-inch (15 cm) ribbon
- map scraps
- scoring tool, bone folder, or dull knife
- glue

1 Fold paper in half lengthwise.

2 Mark the midpoint on the short sides of the rectangle. Fold the corners from the midpoint marks to the center fold of the rectangle as shown. Crease the folds.

3 Punch two holes through both thicknesses. String a ribbon through and tie.

4 Fold in the sides to form a three-dimensional triangle.

5 Cut out map scraps and decorate the front and back of the box.

Triangle Box

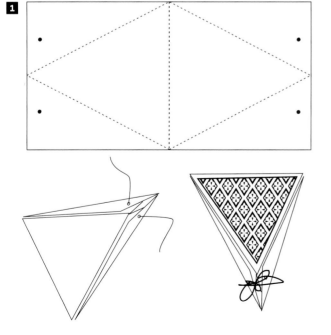

PYRAMID BOX

This little box will surprise and please anyone receiving it, no matter what is inside it. The map you use has to hold a strong crease.

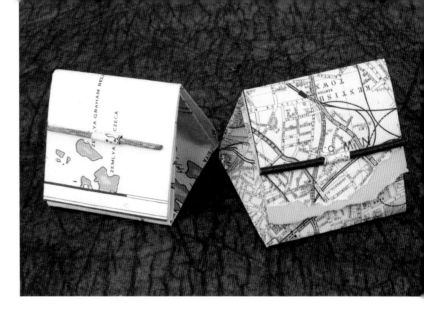

TOOLS AND MATERIALS

- toothpick or small dowel
- cutting tool
- paint (color to coordinate with map)
- paintbrush
- 6 x 8-inch (15 x 20.5 cm) sheet of map paper
- bone folder or scoring tool
- 1 piece of paper (the width of the rectangular hole you cut, and three times that length

1 Cut the sharp ends off the toothpick. Paint it and allow it to dry.

2 Score the map paper in thirds horizontally, as in diagram A.

3 Fold the map paper in half to 4 x 6 inches (10 x 15 cm). Unfold. Fold the outside edges to the center. You should have a grid of squares four across and three down, as in diagram A.

4 Using a steel ruler and cutting tool, cut out the two outside squares on the first panel. Fold that panel toward the back of the map and glue to reinforce the flap.

5 Fold the piece in half lengthwise. Hold firmly and cut a small rectangle in the middle panels on both outside squares, as in diagram A.

6 Lay a small strip of map over the toothpick to create a small tunnel shape, as in diagram B.

7 Push the tunnel shape through the hole on the back panel. Glue the flaps to the inside. This is the latch for the toothpick. See diagram C.

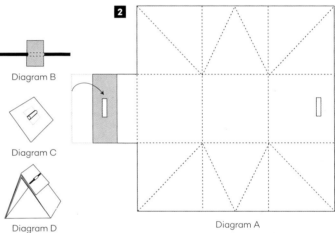

Diagram B

Diagram C

Diagram D

Diagram A

8 Fold the box on the scored lines so the sides lean toward the center.

9 Fold the front flap over so the open rectangle sits on top of the paper tunnel. Insert the toothpick to close, as in diagram D.

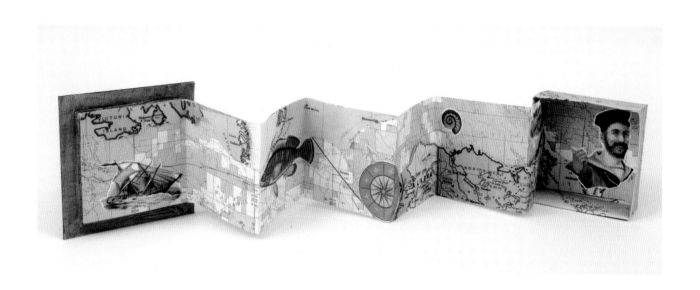

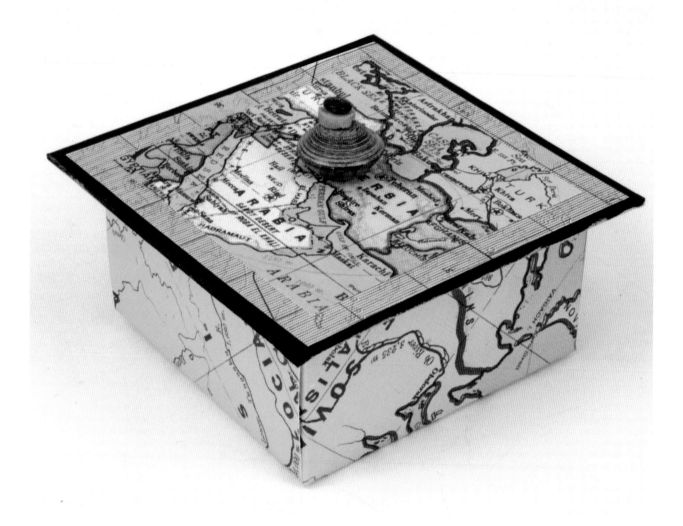

BOOK IN A BOX

This book in a box can be a little treasury, commemorating a special vacation or a collaged fantasy story. Use whatever combination of maps you have that look interesting together to create a journey of the imagination. Decorate the pages with pieces cut out from papers and brochures, clip art, or anything you collected along the way. When you open the box and expand the book, you will have a colorful adventure in a box!

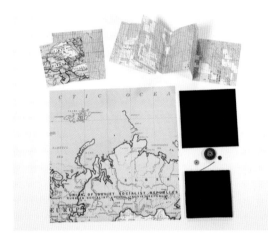

TOOLS AND MATERIALS

- 8-inch (20.5 cm) square piece of map
- 3¼-inch (8.5 cm) square piece of plain paper
- 3-inch (7.5 cm) square piece of map
- pencil
- ruler
- scissors or paper cutter
- glue
- 22 x 2¾-inch (56 x 7 cm) long strip of map for the accordion pages
- map scraps and clip art
- 3½-inch (9 cm) square piece of cardboard for the lid
- 2¾-inch (7 cm) square piece of foam core or thick cardboard
- awl
- pliers
- head pin and beads for knob
- acrylic paint
- paintbrush

Make The Box

1 Turn the large square piece of map face-side down. With the pencil and ruler, draw lines from corner to corner in both directions, making an "X" in the middle.

2 Score on all the dashed lines. Notice that the very center of the box does not have dashed lines. That is the bottom of the box where you do not want folds. After you score the lines, fold the corners into the center. Fold the points outward again as shown.

2

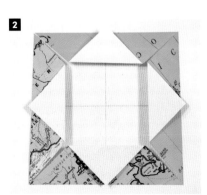

Diagram B

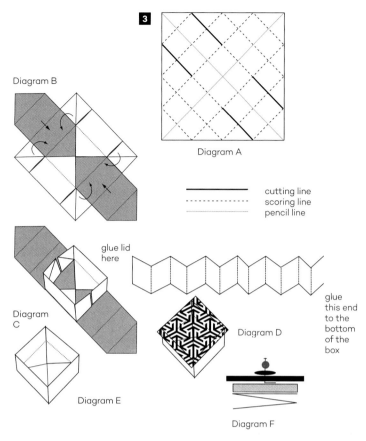

Diagram A

| cutting line |
| scoring line |
| pencil line |

glue lid here

Diagram C

Diagram E

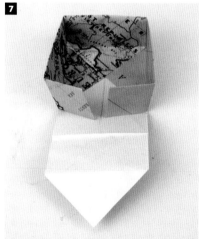

Diagram D

glue this end to the bottom of the box

Diagram F

3 Cut along the bold lines as indicated in diagram A.

4 Fold the two large arrow-shaped sides into the center.

5 Fold the small triangles on that same arrow-shaped side on the crease to make square corners.

6 Fold the last panel of the two sides in toward the center to make sidewalls.

7 On the opposite sides, fold the pointed flap up and over the sidewalls. The point should lie flat inside the bottom of the box.

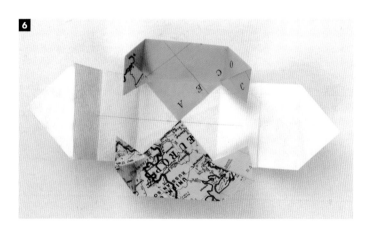

6

7

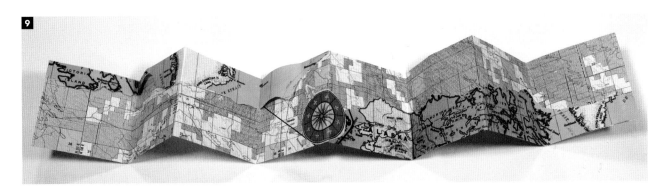

Make the Accordion Pages

8 Fold the long strip of map into an eight-panel accordion.

9 Decorate the eight pages as you wish with maps, clip art, and decorative paper.

Make the Lid

10 Decorate the lid top by gluing the solid color paper then layer the map square on top of the lid piece.

11 Stack the beads on the head pin.

12 Pierce a hole with the awl in the center of the lid. Insert the head pin.

13 On the inside of the lid, use pliers to bend the end of the pin flat.

14 Center the foam core piece and glue in the center back of the lid to cover up the end of the head pin.

15 Paint the inside of the lid. Once dry, glue the first panel of the accordion to the lid. Finally, glue the last panel of the accordion to the bottom of the box.

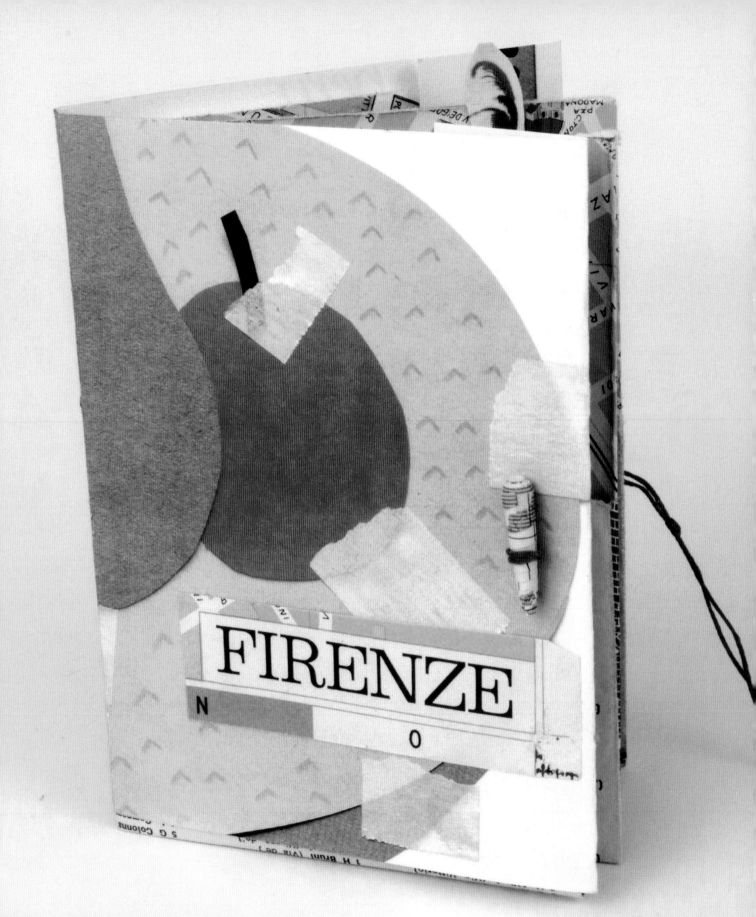

TRAVEL POCKET JOURNAL

This travel journal is full of pockets to hold all of your travel ephemera. It couldn't be easier to make, because it uses the map's existing folds. Road maps are perfect for this project because they are two sided.

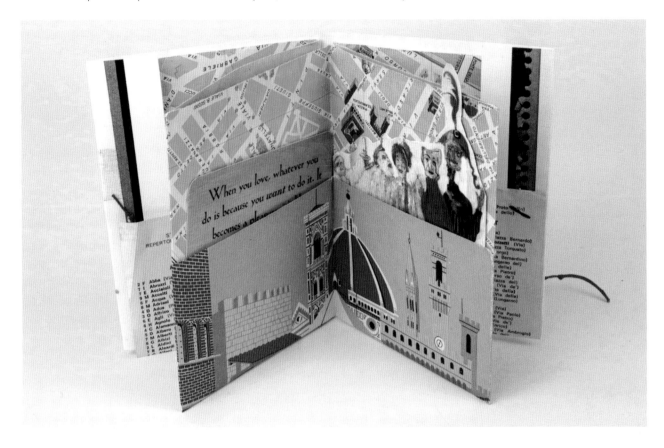

TOOLS AND MATERIALS

- two-sided road map
- cutting tool
- steel ruler
- cover-weight sheet of paper or brochure, 3 times the width of the journal and a little taller
- strip of cover-weight paper, ½ inch (1.3 cm) wide and the height of the book
- ruler
- pencil
- craft glue
- awl or needle
- 2 metal paper fasteners
- ribbon

1 Open up the map and lay it flat on your work surface. Using the steel ruler and craft knife, cut a section of the road map along the horizontal folds, edge to edge.

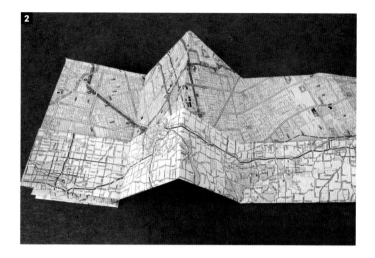

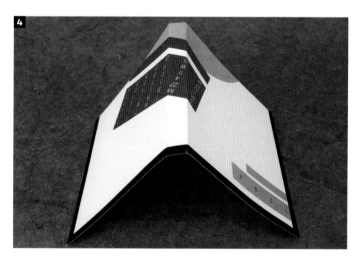

2 Fold up the bottom edge of the map to make a 4- to 5-inch (10 to 12.5 cm)-deep pocket. This will establish the height of the book. Accordion-fold the map along its original fold lines.

3 Make the book's cover and spine. Place the large sheet of cover-weight paper on your work surface, wrong side up. Center the ½-inch (1.3 cm) strip of paper on top of the cover and glue in place.

4 Score both sides of this spine strip and fold.

5 Place the folded map inside the cover, snug to the spine. Make a mark just outside the edge of the map on the inside of the cover. Repeat for the top and bottom, front and back.

6 Fold the edge of the front cover to the inside at the marked points. Repeat on the back.

7 With a needle or an awl, poke a hole in the back cover for the paper fastener. Insert the fastener to hold the text block in place. Repeat on the front cover.

8 Fold the ribbon in half. Wrap it around the head of the fastener on the back cover.

9 Fill up your pockets!

10 Wrap the ribbon around the front fastener to close.

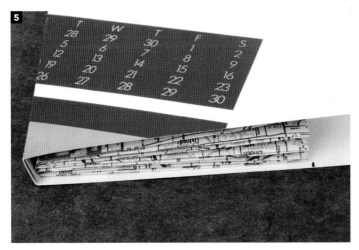

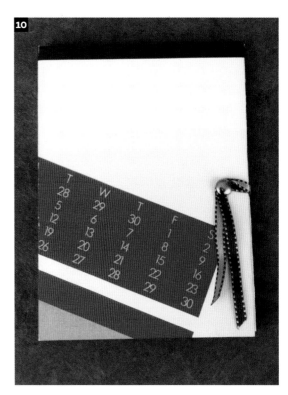

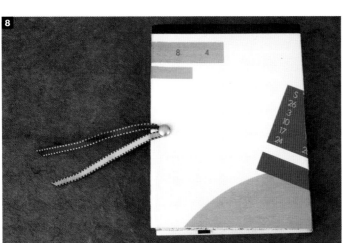

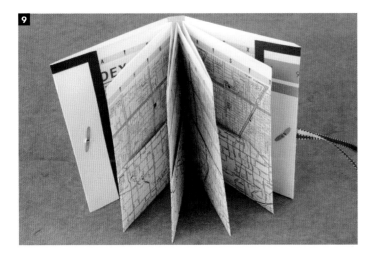

BOOK GALLERY

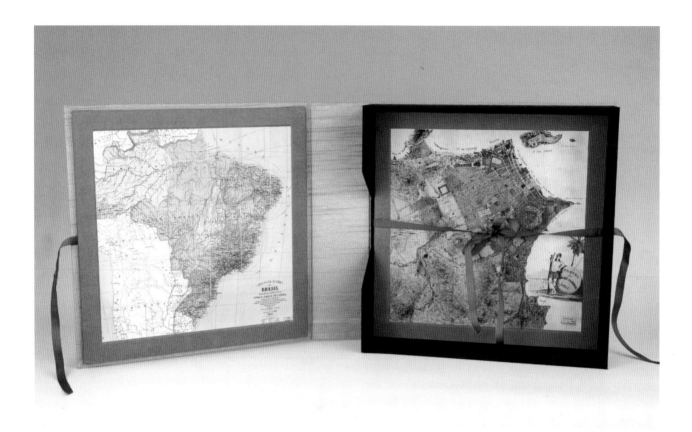

David Ashley

David Ashley has been a calligrapher, bookbinder, and letterpress printer in Denver, Colorado, since 1980, specializing in one-of-a-kind commissions. *A Year in Brazil* is an archival storage box to preserve the mementos of a friend's trip to Brazil. The clamshell box is covered in luxury book cloth and enhanced with a three-dimensional compass rose and antique maps of Brazil. The inner box has a loose board that can be tied down with ribbons to secure the keepsakes inside.

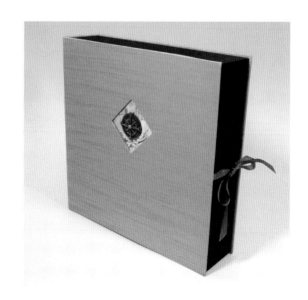

Doug Beube

photos courtesy of the artist

In New York artist Doug Beube's words, *Shifting Borders* alludes to the political and arbitrary reorganizing of property and countries due to political parties in power and tyrannical heads of state. The confusion and reliability of knowing where boundaries begin and end are in question; maps are not definitive but an approximation. Even with GPS technologies that allow us to pinpoint a location, it's still uncertain that travelers will find their destination with ease.

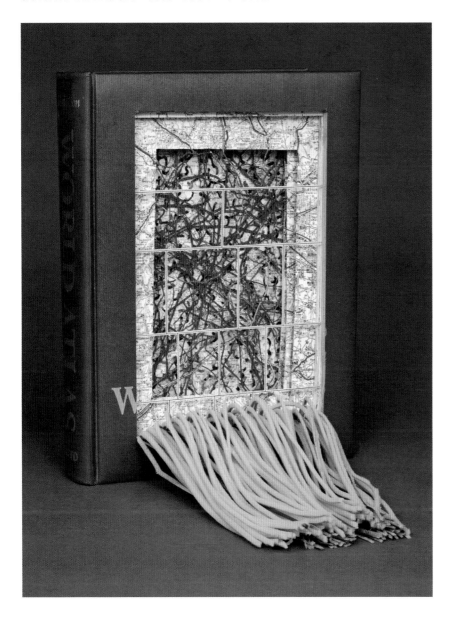

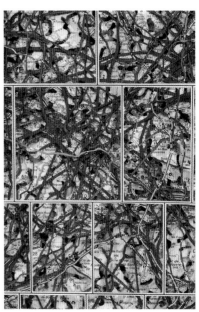

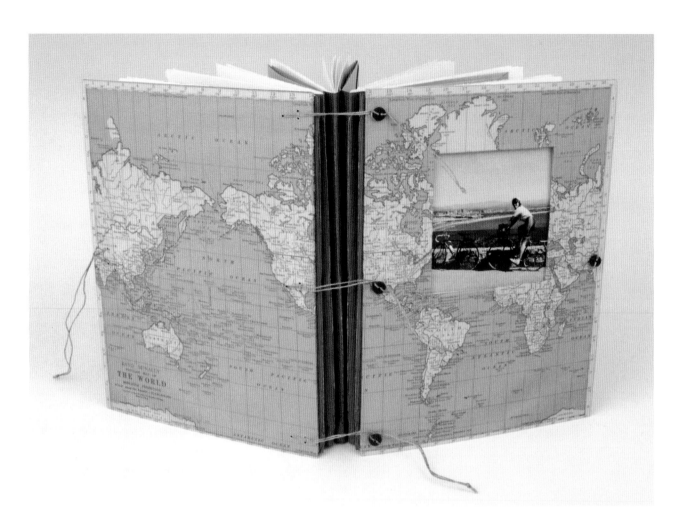

Cindy Leaders

This unique journal features a custom vintage map suited to the adventure's destination. *Expandable Travel Journal* is built on a Pendaflex file pocket that can expand to over 3 inches (7.5 cm). The book includes thirty pockets and envelopes of varying sizes crafted from manila envelopes. The pages are made from 250 gsm French paper that holds up well to all dry media and even watercolor. A window is cut from the front cover so that the owner's photo or art becomes part of the cover design.

Cindy Leaders is a bookbinder who works with vintage elements and unexpected materials. She works out of a sunny home studio in the foothills of the Appalachians in North Georgia.

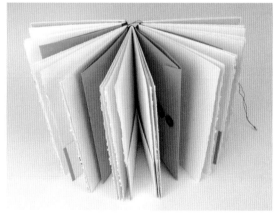

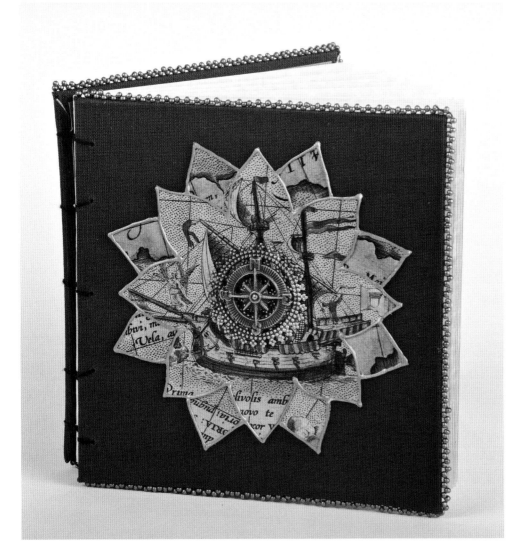

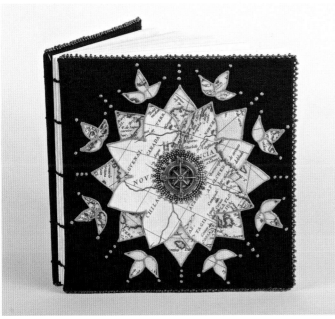

Salyna Gracie

photos courtesy of the artist

"I am drawn to maps as an artistic medium, and vintage maps in particular," says Washington-based multimedia artist Salyna Gracie. "They provide a perfect contemplation of the inner journey. I am fascinated with maps as a unique guide to internal navigation. My map mandala journals are for travels near and far, inner and outer."

Gran Encyclopedia del Mundo (detail)

Julia Strand

photos courtesy of the artist

Julia Strand is a college professor, a scientist, and an artist living and working in Minnesota. She incorporates articulated maps into carved books. Strand carved this piece from a copy of *Gran Enciclopedia del Mundo* that she found at a flea market in Barcelona.

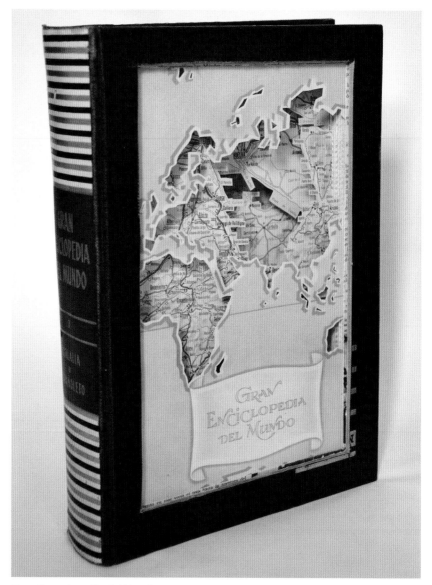

Gran Encyclopedia del Mundo

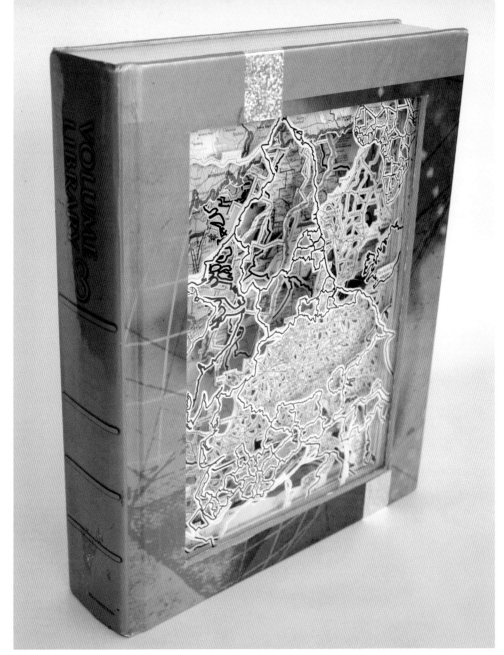

Maps Volume 3

This piece was carved from a 2009 edition of "Volume Library 3," and features maps of Europe, Africa, Vermont, Venezuela, England, Connecticut, Michigan, Long Island, and Iceland.

Maps Volume 3 (detail)

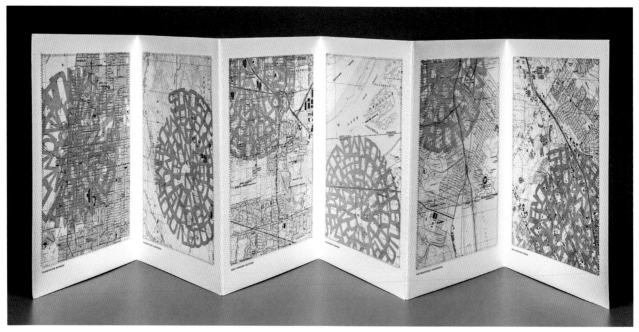

Apparitions Among Us

Lou Cabeen

photos courtesy of the artist

Lou Cabeen lives and works in Seattle, where she balances her working life as an artist with her working life as an associate professor of art at the University of Washington. In both arenas she is a passionate advocate of the tactile joys of fiber and textiles, especially stitching. For the past several years she has combined this passion with an equally avid attention to maps, mapmaking, and book arts. *Apparitions Among Us* consists of four six-panel accordion books, each revealing the locations and stories behind contemporary apparitions of the Virgin Mary. (Above)

Studies for a Non-Historical Atlas is site specific work about Old Town Montreal. (Right and opposite page.)

Studies for a Non-Historical Atlas: Origins

Studies for a Non-Historical Atlas: Language (detail)

Non-Historical Atlas: Mountain

Studies for a Non-Historical Atlas: Mountain (detail)

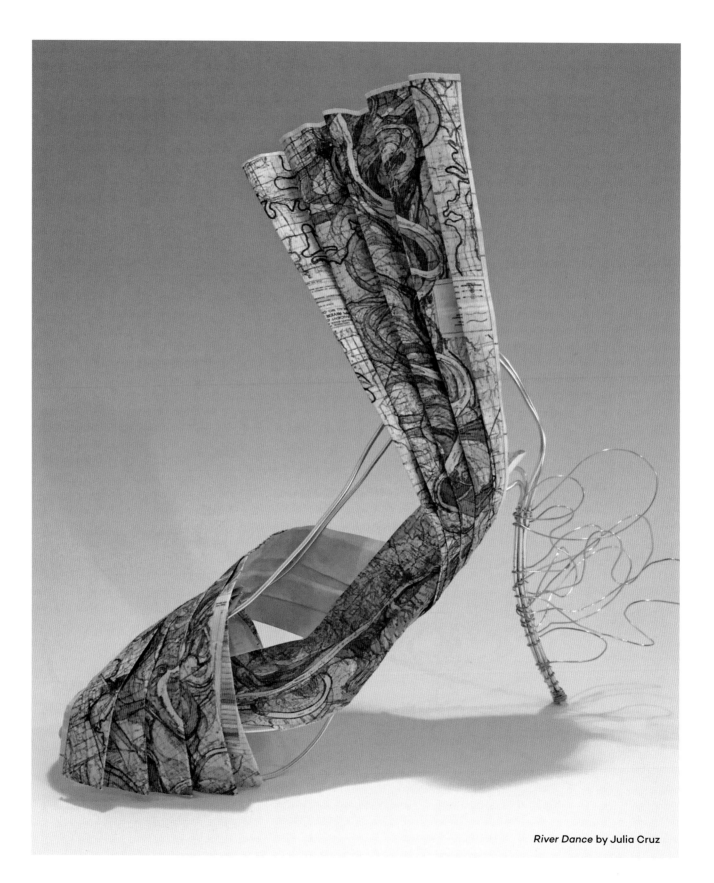

River Dance by Julia Cruz

FASHION

The colors and patterns of maps are so appealing, it's no wonder they've been printed on fabrics for scarves, neckties, shirts, handbags, and luggage. Artists make use of maps in fashion in clever ways, whether wearable or not. In this chapter you'll find jewelry you can make yourself, fantasy hats, impractical shoes, a folding fan, and a gallery of fashionable cartographic garments and accessories.

HAT PARTY

I invited five of my friends with varying levels of crafting experience to join me on a snowy day to make map hats. Crafting hats from maps adds an element of arty, cartographic flair (and a lot of laughter) to a bon voyage, welcome home, or birthday party. There are no rules for this project. The end results are simply up to everyone's personal style, creativity, and whatever materials are at hand.

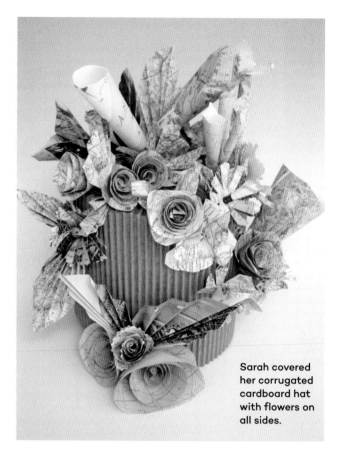

Sarah covered her corrugated cardboard hat with flowers on all sides.

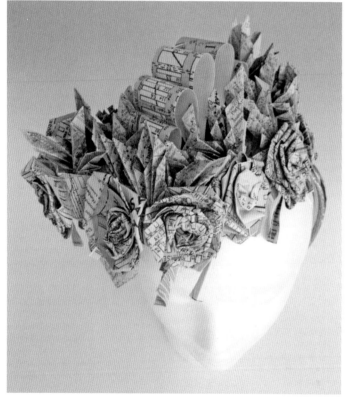

Deedee topped her hat with roses.

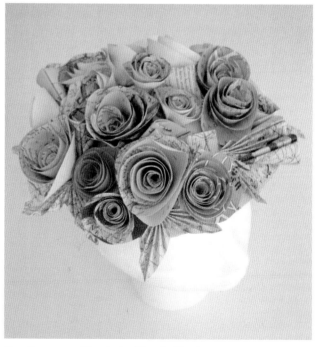

Rosalba covered her hat with spiral buds.

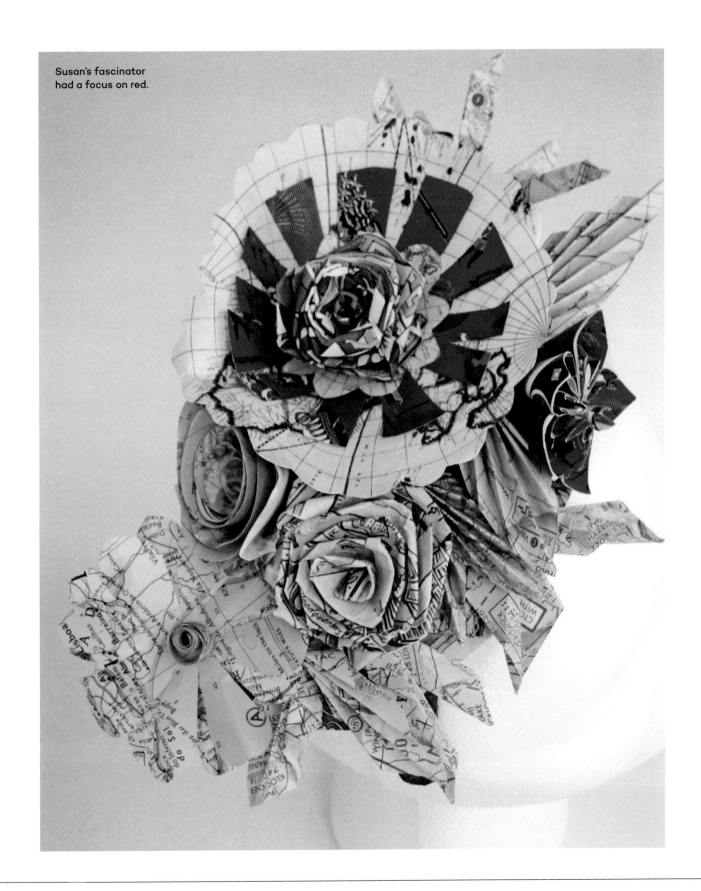

Susan's fascinator had a focus on red.

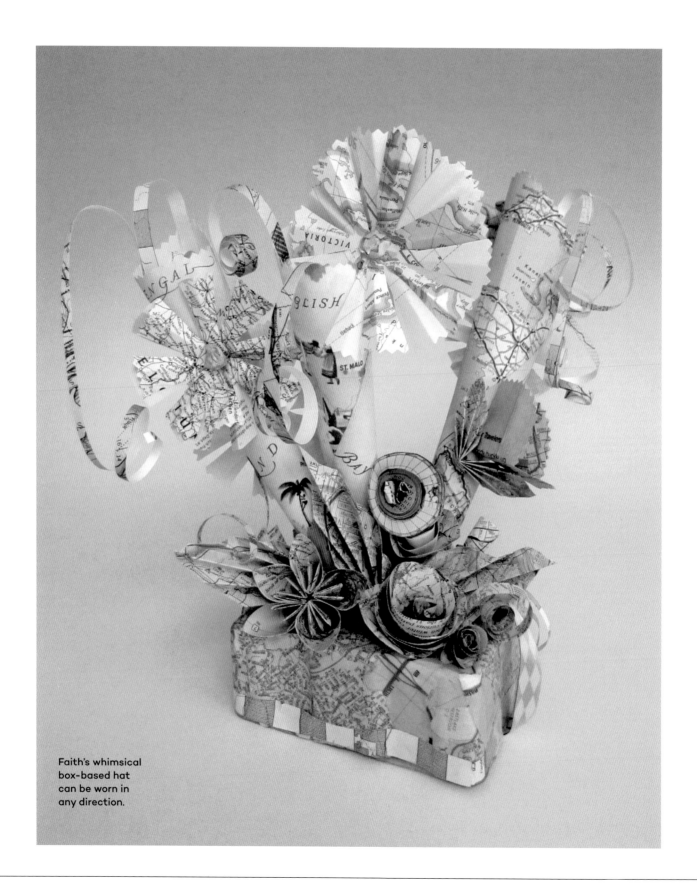

Faith's whimsical
box-based hat
can be worn in
any direction.

TOOLS AND MATERIALS

- trimmings: flowers, cones, tendrils, and leaves (page 18)
- base materials: cardboard, old hats, small boxes, headbands, and shoulder pads
- map scraps
- glue gun
- scissors
- craft knife
- hair clips
- ribbon

1 Choose and assemble a hat base. Make a base for a fascinator with a plastic headband and a shoulder pad. Cut two slits on one side of the shoulder pad, being careful not to cut through all thicknesses. Slide the headband through the slits.

2 A plastic cookie tray or a small box can make a lightweight square base for a hat. Center and attach a ribbon at the top of the hat before adding the trimmings, so that you can tie the hat under your chin later.

3 You can cut and shape a piece of corrugated cardboard into a variety of shapes for a hat base. Hold the tucks and overlaps in place with staples, tape, or hot glue. The simplest way to start is to wrap a length of corrugated cardboard around your head for a tall hat.

4 Make a collection of map-based flowers, leaves, tendrils, and cones. You'll find directions for these, including several types of flowers, in "Foundational Basics," which starts on page 12. Have plenty of trimmings available for your guests.

5 Use the glue gun to attach each element to the base. If you're using craft glue, hair clips will hold elements in place until the glue is dry. Add ribbons and bows as needed.

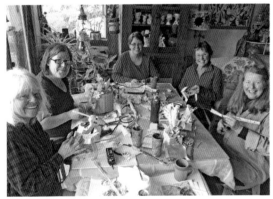

From bottom left:
Deedee Hampton,
Sarah Bassow,
Rosalba Lucero,
Susan Anderson,
and Faith Evans.

JEWELRY

Where can you wear a map? Just about anywhere—on your ears, wrist, neck, or head. Jewelry made from maps adds color, texture, and meaning to your fashion look.

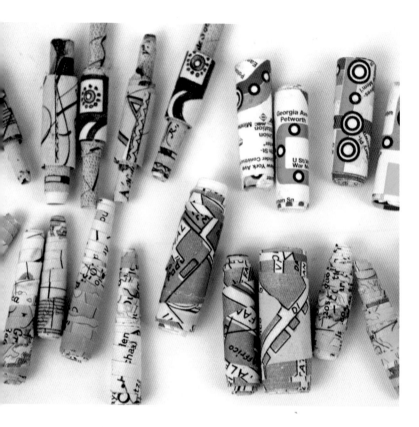

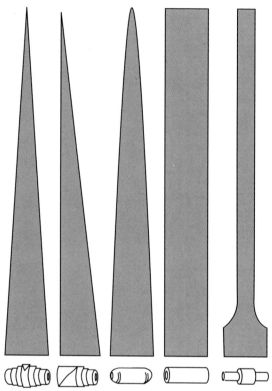

Paper Beads

These five bead shapes are all made from bits of map wrapped around a thin dowel, wooden skewer, or toothpick. When the glue is dry, seal the beads with a water-based varnish for a more permanent surface and longer life in your jewelry.

TOOLS AND MATERIALS
- small strips and pieces of map
- skewer, dowel or toothpick
- glue
- matte varnish
- brush

1 Choose a dowel, skewer, or toothpick based on the size of the hole you need.

2 Wrap the paper, any shape, around the base tightly.

3 Glue the very end of the paper in place. Allow the glue to dry.

4 Varnish the bead with spray or liquid matte varnish to seal.

Earrings

Use lightweight map beads (page 72) to embellish purchased hoop earrings, like this rectangular silver set. The maps add the intrigue of foreign places.

TOOLS AND MATERIALS

- craft wire
- wire cutter
- wrapped beads
- purchased hoop earrings
- needle-nosed pliers

1 Insert a small length of wire into the bead.

2 Wrap one end of the wire around one side of the hoop. Position the bead, then wrap the wire around the other side of the hoop. Trim the wire and use needle-nosed pliers to tuck the wire inside a bead.

3 Continue to set in beads and wrap with wire until you have filled the desired area.

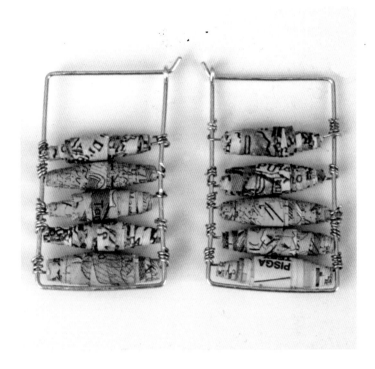

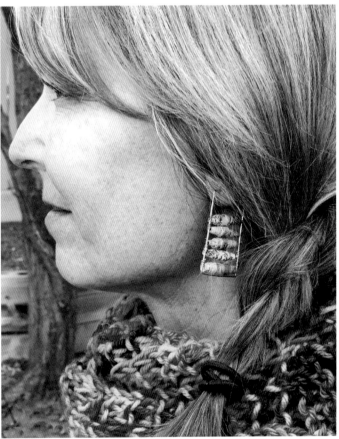

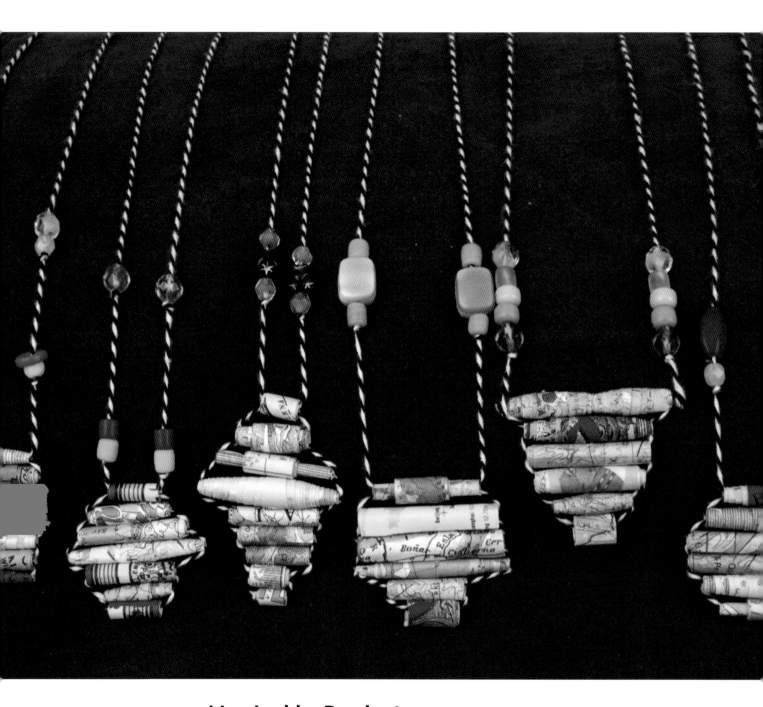

Map Ladder Pendants

This necklace design makes a great group project for kids or adults. Make lots of beads according to the instructions on page 72. Set them in the middle of the table so everyone can choose five or six to string for a necklace. It's an easy and colorful project for a rainy day.

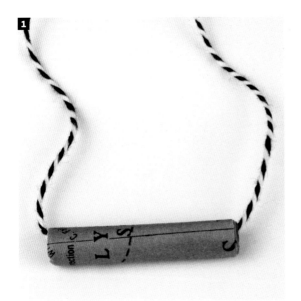

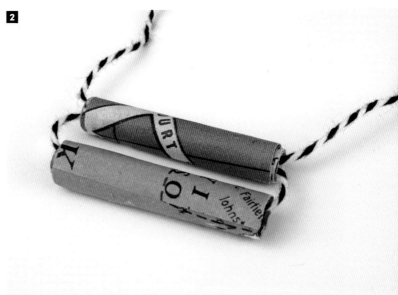

TOOLS AND MATERIALS
- map beads (page 72)
- 1 yard (1 m) baker's twine or string
- scissors
- glass beads of various sizes
- closure findings (optional)

1 Thread the string through the bead that will be at the bottom of the pendant.

2 Add the second bead. Insert the right-hand string into the second bead going to the left. Insert the left-hand string going to the right.

3 Repeat step 2, adding beads in whatever design you like. Tighten the string as you go. When you reach the top bead, place a dab of glue inside to keep the string in place.

4 Add glass beads to the string, making a knot on either side to keep them from slipping.

5 Tie the ends of the string, creating a wide enough loop to fit over your head, or tie a clasp to the ends of the string as a fastener. Trim the excess string.

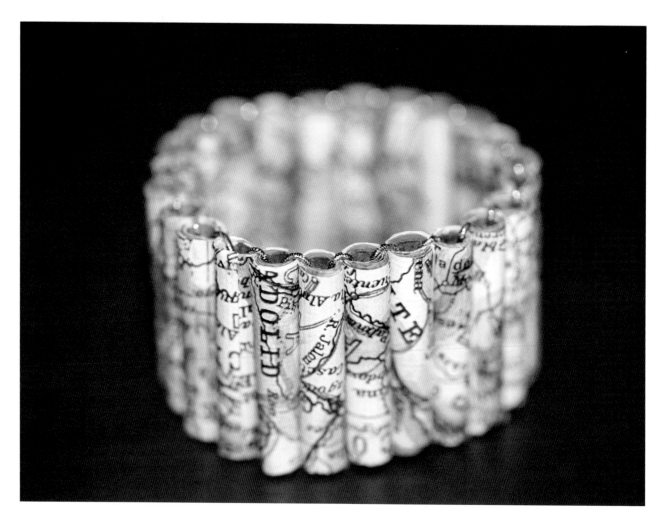

Big Beaded Bracelet

This bracelet starts with beads made with bits of map over a colored-paper core. It's woven with metallic elastic cord to add a bit of bling and to make it easy to slide off and on.

TOOLS AND MATERIALS

- 24 pieces 1½ x 4 ½-inch (1.3 x 11.5 cm) colored paper for bead core
- bamboo skewer
- 24 map papers 1½-inch (1.3 cm) square
- matte adhesive
- matte varnish
- brush
- 2 pieces elastic metallic cord, 1½ yards (1.4 m) each

1

2

4

5

7

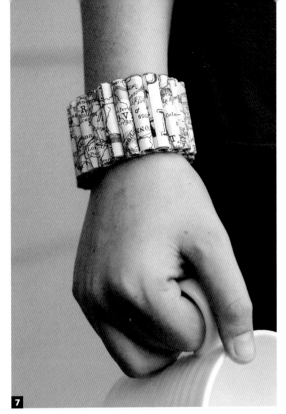

1 Using the colored paper, make 24 tubular beads (page 72), wrapping the paper around the bamboo skewer. The hole in the center needs to be large enough to accommodate two pieces of the elastic cord.

2 Wrap the map squares around the outside of the paper beads, gluing the ends into place.

3 Paint the finished bead with matte varnish. Allow the varnish to dry thoroughly.

4 Tie the elastic cords to the skewer, one bead length apart. String on one bead at a time, feeding the cord through the beads in opposite directions.

5 Pull the cords firmly to keep the beads snug against each other.

6 When the last bead has been added, untie the cord from the skewer, then tie the cord tops and bottoms to each other. Trim the ends of the cords to about a ½ inch (1.3 cm).

7 Slide the knots inside a bead so they do not show. Slide the bracelet onto your wrist.

SHOES

What could be more reflective of life's journeys than a map and a pair of shoes? It turns out maps and shoes pair up beautifully. Use a well-loved pair or a thrift-shop find. The more wear and tear, the more poignant the story.

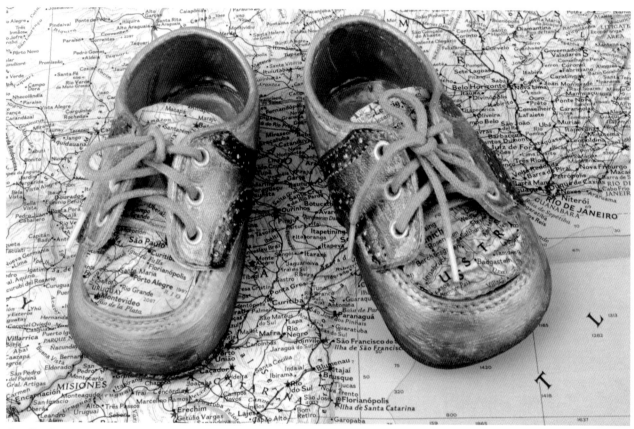

Acrylic glazes and maps on baby shoes.

Oh the Places She'll Go

I created this piece in homage to my daughter. She's leaving our home to live in another country as an exchange student. I wanted to commemorate how fast she grew up by adding maps of the places she is going and places she has been.

River Dance

These fantasy shoes were created by Julia Cruz, a multimedia artist in Orange, California. Cruz uses different media to reflect the subject of her pieces. In this case, she used maps of the Mississippi River and wire. The organic flow of the river mirrors the lines of the foot that follows it downstream.

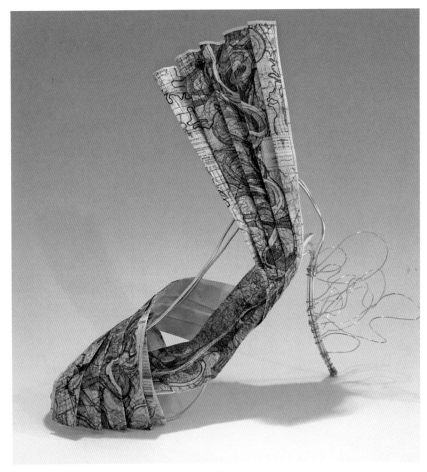

Mississippi River paper maps and metal wire.

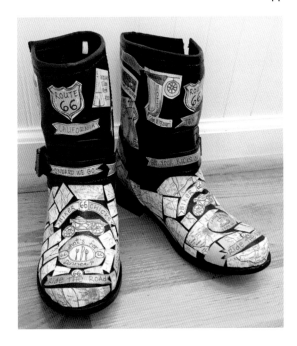

Biker Chicks

California artist Jamie Fingal decorated these upcycled boots with maps and drawings based on a girls' road trip that was planned around tourist attractions, eateries, and coffeehouses.

FOLDING FAN

Who knows when you might crave a breath of fresh air. Having a one-of-a-kind folding fan in your pocket not only puts a colorful face on practicality, but it's also a great conversation starter at parties. This one is easy to make and folds down to an efficient size for taking along on any occasion. Use a two-sided map so the fan will be attractive any way you hold it. **Fans by Rosalba Lucero**

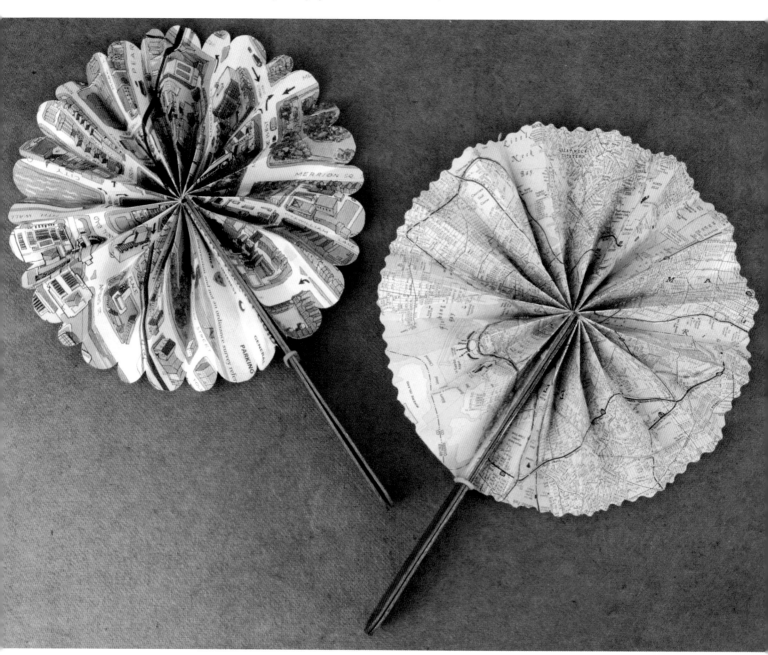

TOOLS AND MATERIALS

- 4 x 32–inch (10 x 81.5 cm) two-sided paper map
- decorative scissors (optional)
- corner rounder tool (optional)
- 2 large craft sticks
- craft knife
- ruler
- acrylic paint
- brush
- rubber band
- glue
- glue brush
- paper clip
- ponytail elastic

1 Trim one long edge of the map with decorative scissors, if desired. This will be the outer edge of the fan.

2 Accordion-fold the map into 32 panels.

3 Round the corners of the panels, if desired.

4 Use a ruler and craft knife to trim off one end of each craft stick. Paint the craft sticks and allow them to dry.

5 Glue a craft stick to one end of the accordion-folded map, flush with the top. Repeat at the other end of the accordion with the second craft stick.

6 Wrap a rubber band around the stack to compress it. Apply glue to the spine and allow it to dry.

7 Remove the rubber band. Open the fan. Use the ponytail elastic on the handles to keep the fan open or closed.

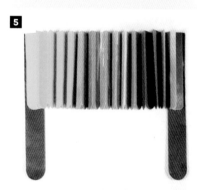

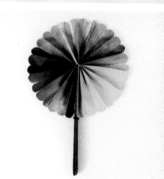

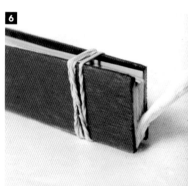

FASHION GALLERY

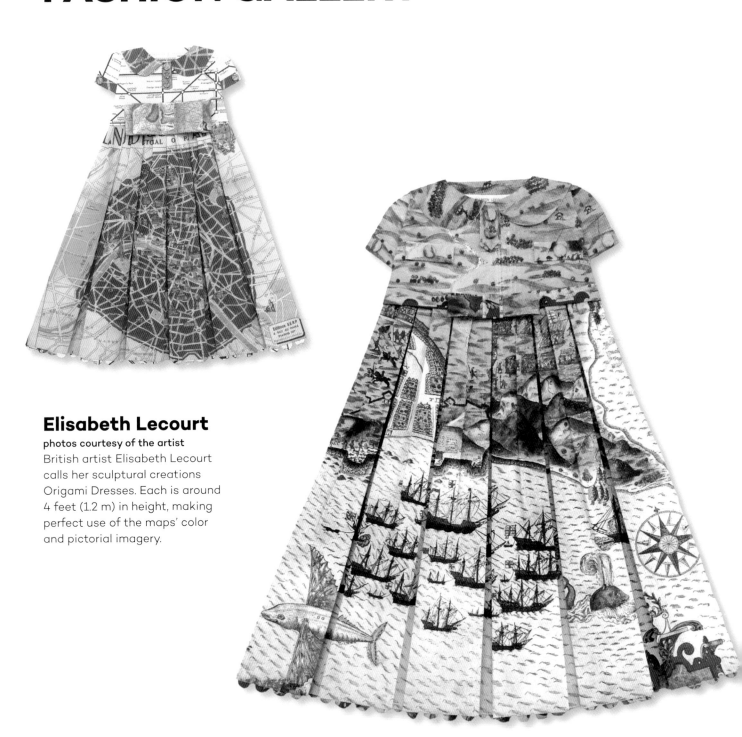

Elisabeth Lecourt

photos courtesy of the artist

British artist Elisabeth Lecourt calls her sculptural creations Origami Dresses. Each is around 4 feet (1.2 m) in height, making perfect use of the maps' color and pictorial imagery.

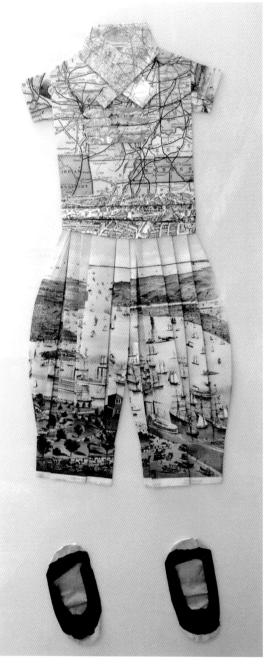

*Les Pantalons
du Professeur Cambodia*
Maps of New York
and London, shoes
with pom-poms

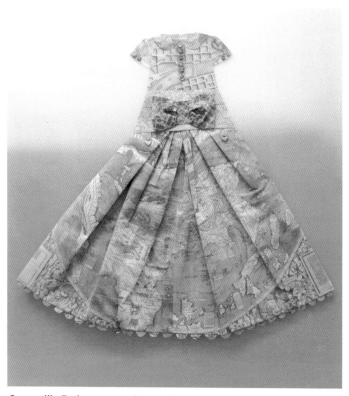

Grenouille Embrasse son Crapaud
Mixed maps of Peru, Paris, and the world

Sharon Erlich
photos courtesy of the artist

"My Map Artistry jewelry started when I was looking for gifts to get my nieces who were leaving on study-abroad programs," says Sharon Erlich. "It's grown from there. Each necklace is conceived, constructed, and designed by me to take advantage of the inherent shapes, lines, and colors found in road maps and city 'tourist' maps from various countries. Most of the maps have been collected from my travels over the years. No two necklaces are identical. Each map necklace is reversible and can be worn on both sides, displaying different colors, tones, and locations."

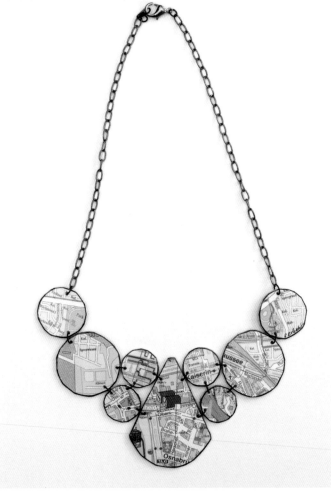

Berlin Circles

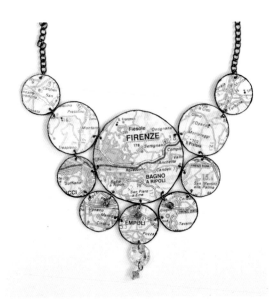

Firenze Circles

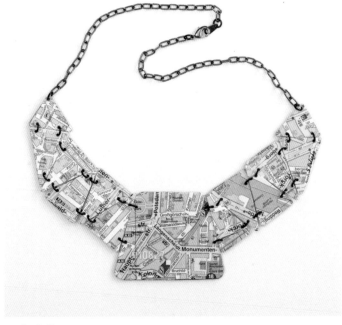

Berlin Collar

Liz Hamman

photos courtesy of the artist

British artist Liz Hamman has been creating jewelry from unwanted books and maps since 2007. She uses various methods to manipulate the paper, including origami and laminating, carving, and stacking paper. The methods used are often a direct response to either the subject matter of the book or the quality of the paper. She is inspired by geometry, growth patterns in nature, and repetitive structures and processes.

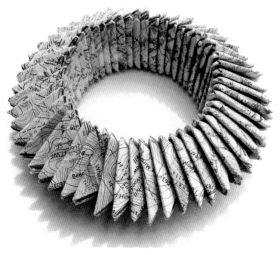

Cumbria Bracelet

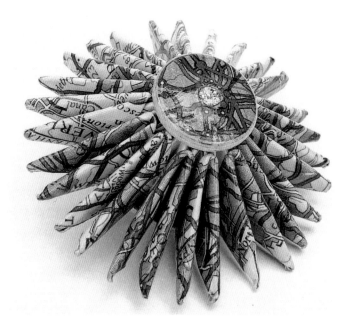

Birmingham Brooch

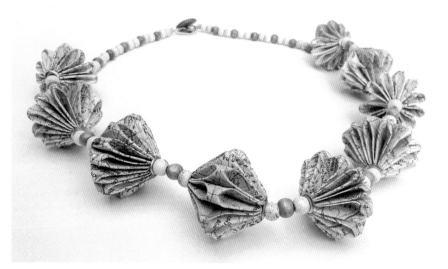

Necklace

Rosalba Lucero

Rosalba Lucero is a self-taught artist in Colorado. She hails from Mexico, and brings to her art the colors and textures of that culture. This fan was inspired by flamenco dancing, which is one of her passions.

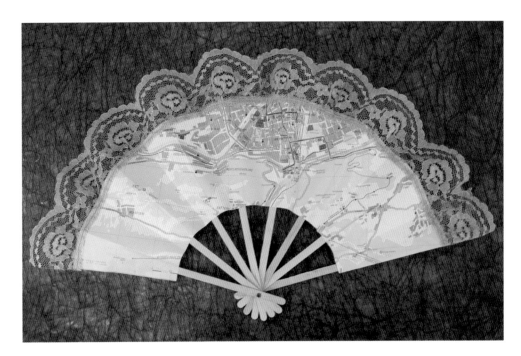

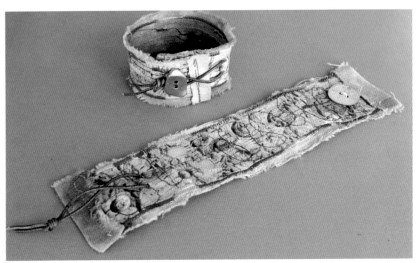

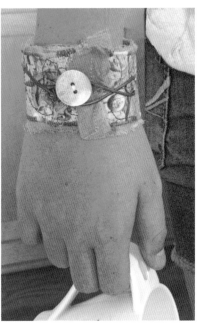

Diana Trout

Diana Trout, a mixed-media artist from Pennsylvania, is known for her journaling and book art. She created her *Lunar Cuff Bracelet* with "paper cloth" made with maps from the *Atlas of the Moon* printed on Arches paper and hand-dyed indigo cloth. To finish, she added machine stitching and a silver button and leather closure.

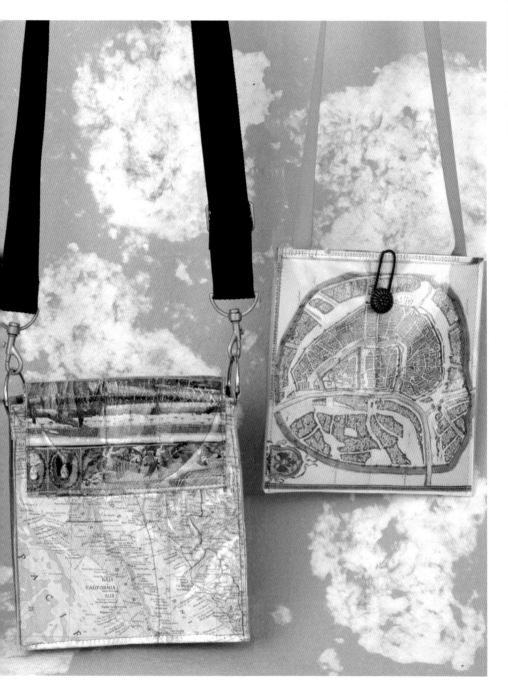

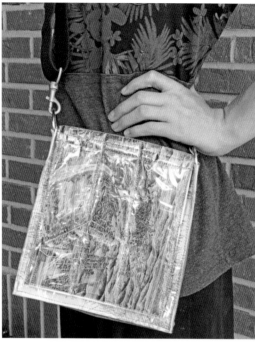

Gwen Diehn

Gwen Diehn is a printmaker from North Carolina. She also designs and fabricates bags and wallets from materials—including maps—that were headed for the landfill. "My wallets and bags are fun to use and eminently practical. I specialize in custom designs and working with clients to modify or create entirely new designs to perfectly fit their specifications."

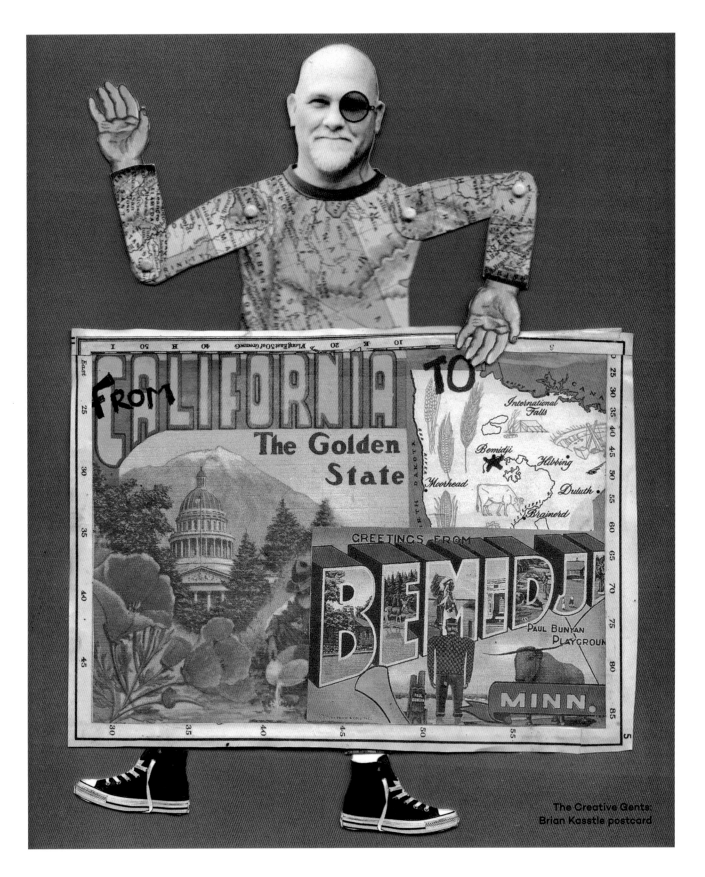

The Creative Gents:
Brian Kasstle postcard

COLLAGE AND ILLUSTRATION

With their insets, keys, cartouches, and borders, maps often look like collages just the way they are printed. They are, in fact, an ideal material for paper collage and mixed-media work. The shapes of islands and countries, divisions created by rivers and mountain ranges, latitude and longitude demarcations, and interesting blends of type styles call out to collage artists as figures, new lands, animate objects, and transformed landscapes. This chapter will make you want to hang on to every scrap of map you own, and use it to create something new.

PAPER DOLLS

Maps suggest parts for paper dolls pretty easily. Half a globe makes a perfect full skirt. Dense type and roadways turn into an elegant blouse pattern. Bits and pieces of maps pair beautifully with other bits of paper ephemera and your own drawings. There are no rules here.

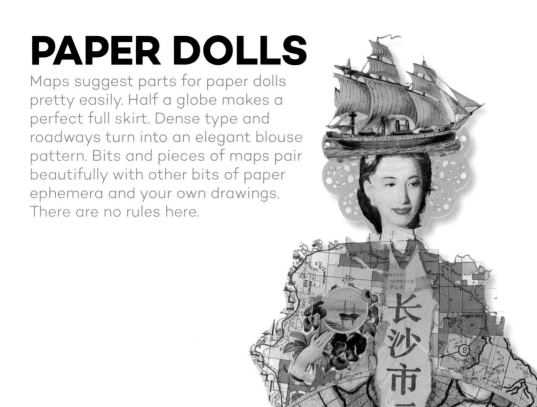

TOOLS AND MATERIALS

- maps
- scraps of papers and doilies
- face and other body parts from photos, magazines, or drawings
- piece of background paper
- scissors
- glue

1 Gather bits of maps, papers, and clip art that suggest clothing and details for your paper doll.

2 Cut the maps and scraps into fashion components: hats, skirts, shirts, scarves, shoes, jewelry, belts, and blouses. Cut out a face and arms. Arrange the pieces in any style you like, gluing all the parts in layers. Glue the doll onto a backing, if desired.

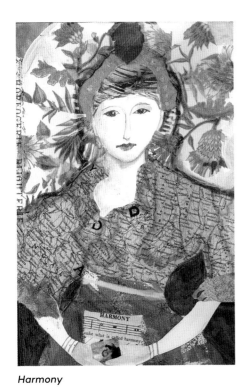
Harmony

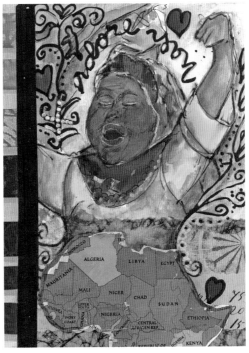
Africa

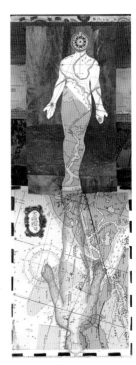
Body Reflections

JOURNAL MAPS

Journaling is a regular part of my artistic life. So is traveling. I love to combine the two by decorating my journals with maps, and so collage is a natural for me. Try it on your travels using whatever papers are handy. A glue stick is easy and dripless to carry with you.

TOOLS AND MATERIALS

- maps and scraps
- adhesive
- scissors
- markers or paint to add details

1 Use a map to add clothing or a background to a drawing in your journal.

2 Cut out a shape from a map and glue it over a journal page.

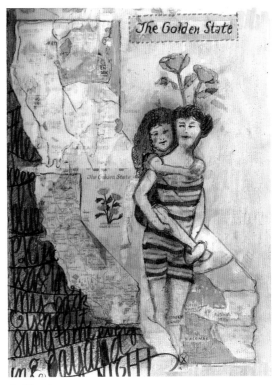
California

DECONSTRUCTED POSTCARDS

This is a project you can start, set aside, and come back to. Do it in phases, or gather all of your maps, scraps, and ephemera and do it all at once. It's a great project to enjoy with a group, and a clever way to create mailer invitations for a special occasion.

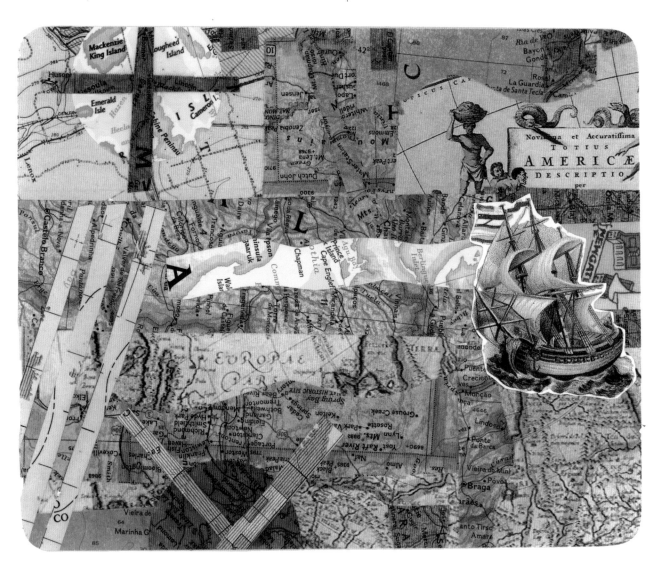

1

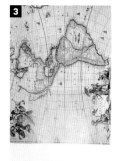

1 Paint the neutral maps different colors. Allow the paint to dry.

2 Cut the painted maps into pieces, any shape. Use the hole punch to make circles.

3 Brush gel medium onto the backs of the vintage map copies. Glue the maps to the poster board. Use the credit card to smooth out any wrinkles or bubbles.

3

2

4 Glue pieces of cut-up painted maps on top of the vintage maps. Don't worry too much about composition. Turn the paper as you work so that the placement and design stays random. Continue adding map pieces, cutting them in different shapes and sizes. Be sure to leave some interesting elements of the vintage maps visible.

5 Add circles, stripes, wavy lines, rectangles, and clip art, until the design balances as you like.

6 Paint a coat of matte gel over the finished piece. Allow the gel to dry thoroughly.

7 Turn the collage face down. Use the pencil and ruler to measure six postcards.

8 Cut out the postcards and round the corners if you like, as shown on the opposite page. Mail them to friends!

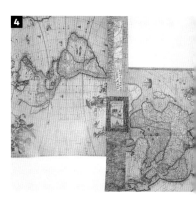

4

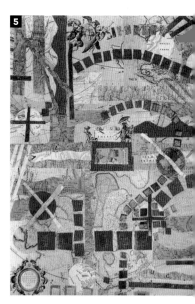

5

TOOLS AND MATERIALS

- watercolors or acrylic glazes
- brush
- scissors
- plain colored or black and white maps
- large hole punch
- copies of vintage maps
- matte gel medium or adhesive of choice
- glue brush
- 14 x 17–inch (35.6 x 43.2 cm) piece of posterboard or postcard-weight paper.
- credit card or hotel card
- corner rounder tool (optional)
- clip art
- pencil and ruler

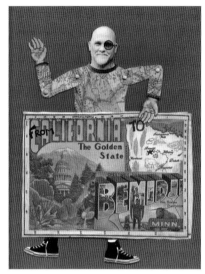

Brian

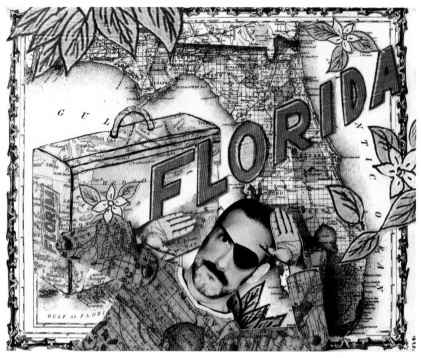

Thomas

CREATIVE GENTS POSTCARDS

photos courtesy of the artists
The Creative Gents, mixed-media artists Terry Garrett, Brian Kasstle, Thomas LaBadia, and John Arbuckle, meet each year in different locations around the United States. This year they decided to pre-celebrate the event by making postcards.

Terry used his expertise to create map-patterned articulated paper dolls after Thomas used his Photoshop magic to design the heads. (Those are the gents themselves under the eye patches and monocles!)

Within a week, body parts were flying over emails from Florida to Minnesota. The completed dolls were mailed to each gent, who then created postcards. All designs were based purely on individual creativity. No demands were made other than including the gents' home state and retreat destination—Bemidji, Minnesota—in each individual card.

Terry emphasized the local folklore of Paul Bunyan and Babe the Blue Ox through ephemera from vintage Minnesota postcards. John included not only his home state of Washington but also used portions of the other gents' states of Florida, Minnesota, and California in his design. Thomas was ready with his bags packed, as his postcard shows. And, using the California poppy, Brian tied his postcard ephemera together through a focal color. Next on the Creative Gents' collaboration calendar is a self-portrait round robin.

John

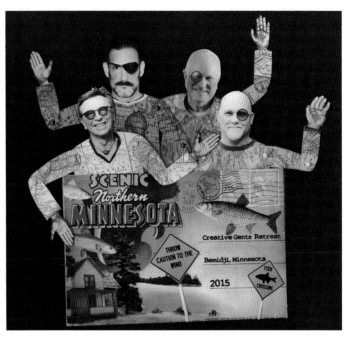

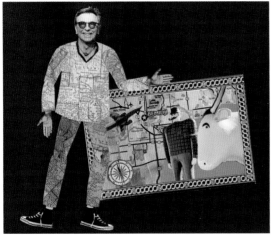

Terry

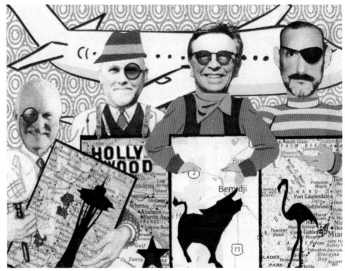

Thomas

COLLAGE GALLERY

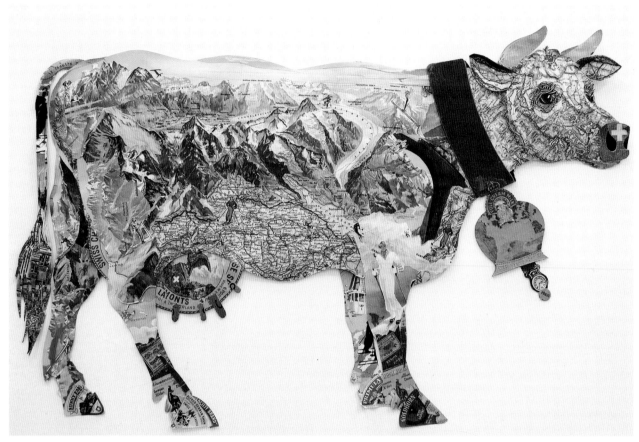

Swiss Miss 2

Peter Clark

photos courtesy of the artist

British artist Peter Clark uses a comprehensive collection of found papers that are colored, patterned, or textured with printed, written, or worn surfaces. With this media he "paints" his collages. He shades his figures with density of print and creates substance and movement with lines plucked from old maps or manuscripts.

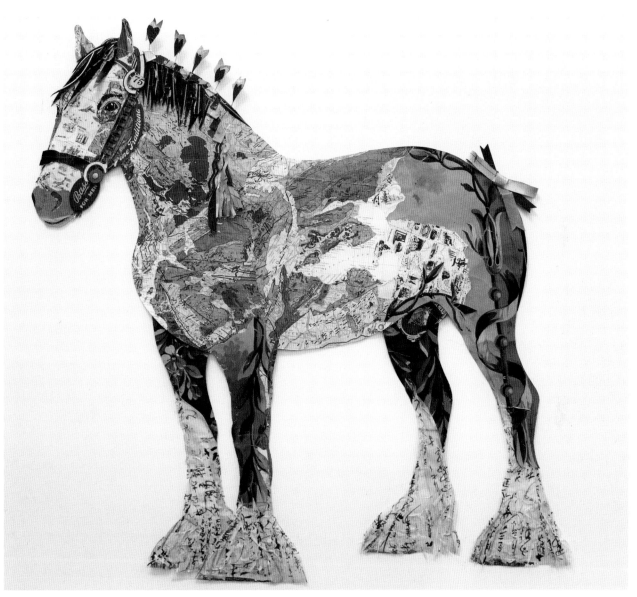

Feather Foot

Joao Machado

photos courtesy of the artist

Portrait and *Blue Queen* are part of a last, closing chapter of a map series based on women's portraits that Brazilian artist Joao Machado worked on from 2006 to 2015. They were made for an exhibition with the theme of identity at the Rauchfeld Gallery in Paris.

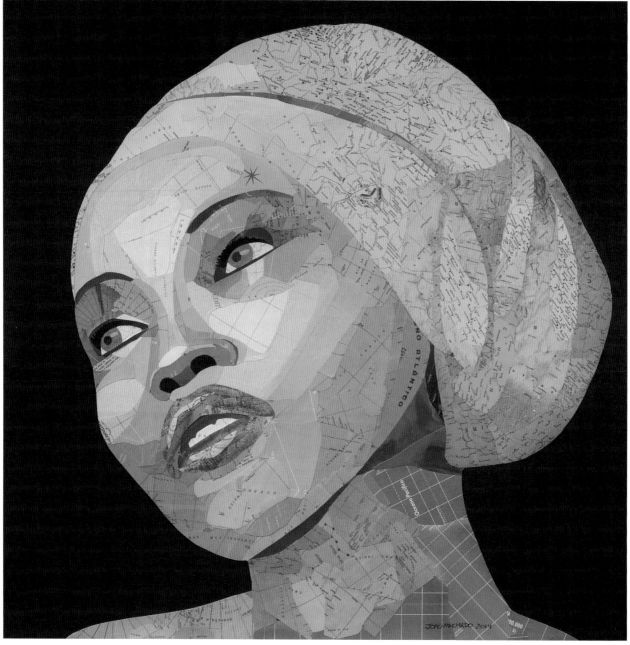

Blue Queen

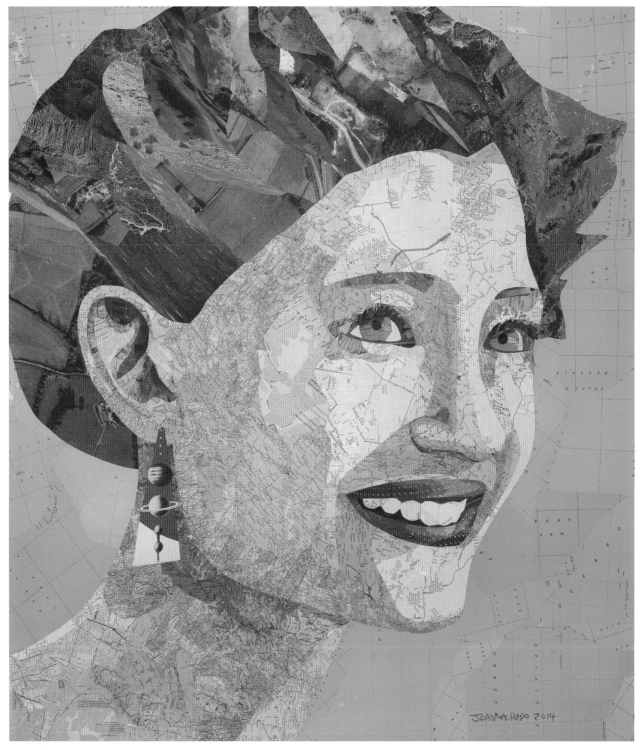

Portrait

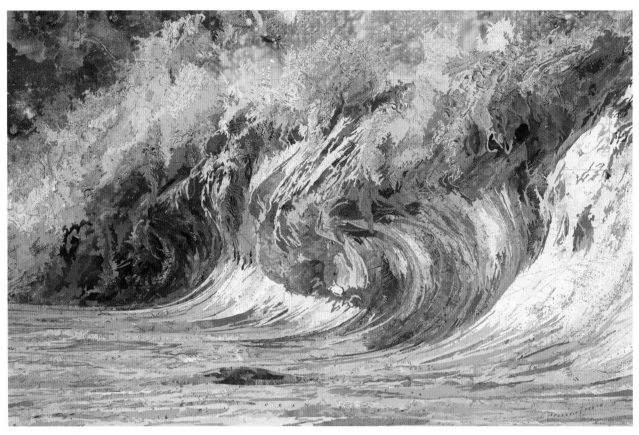

Genevieve's Wave

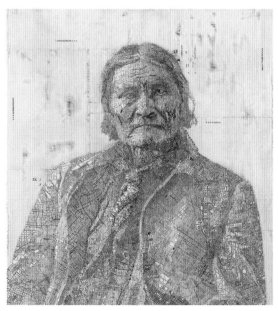

Geronimo

Matthew Cusick

photos courtesy of the artist

"Although I employ a broad range of materials and
techniques, working with maps has been the focus
of my studio practice since 2002," says Texas-based artist
Matthew Cusick. "I use maps as a surrogate for paint and as
a way to expand the limits of representational painting.
By appropriating the language of cartography, the hybrids
of topography and image that my map collages explore
are also layered with textual, abstract, and representational
interpretations. The map collages are both objects
and stories, using actual cartographic artifacts from
our collective history to reinvigorate pertinent
geographic narratives."

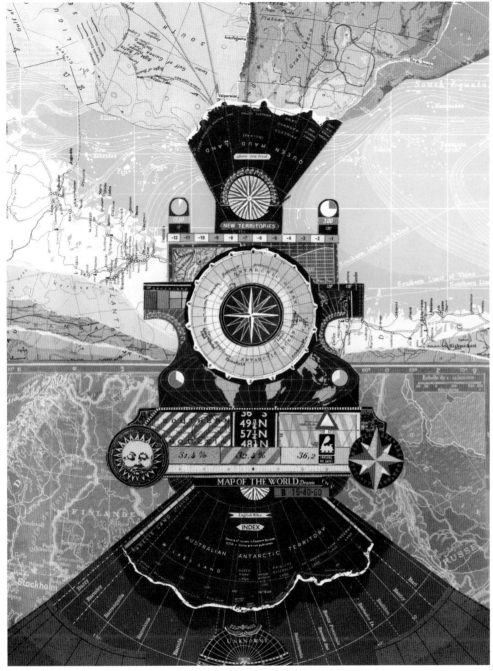

Martin O'Neill

photo courtesy of the artist

London-born, Irish-bred Martin O'Neill is an illustrator and artist who creates unique handmade collages for a wide range of international clients in publishing, advertising, and design. He works largely by hand, developing his images from a subtle alchemy of collage, silkscreen, paint, and photocopies, and draws from a large archive of found and self-generated material housed in his studio. *Station to Station* was pieced from fifteen vintage atlases.

Station to Station

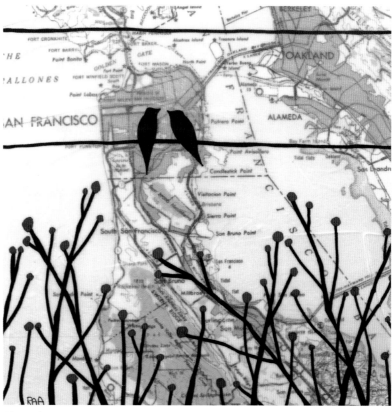

Alameda

Rachel Austin

photos courtesy of the artist

Rachel Austin is a self-taught artist living in Portland, Oregon. Her paintings begin with a map. They are then covered with acrylic medium, oil paint, and ink on wood panels. Because of the layers, each painting takes between a week and two weeks to complete. Each is named after a location on the map and framed with handmade wood frames.

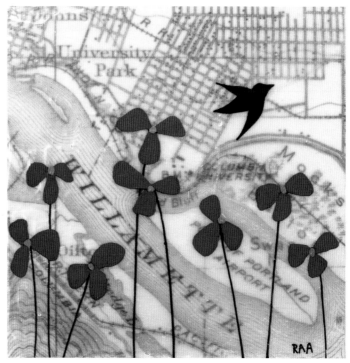

University Park

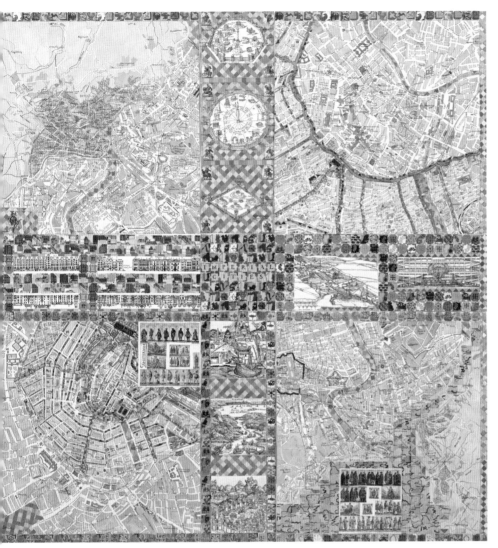

Imperial Cities

Joyce Kozloff

photos courtesy of the artist

New York–based artist Joyce Kozloff uses maps as a focal point for her politically engaged mixed-media works. *Los Angeles Becoming Mexico City Becoming Los Angeles* was inspired by the racial tensions and physical damage caused by riots and earthquakes in Los Angeles around 1993.

For *Imperial Cities*, Kozloff sliced and recombined maps of four former imperial capitals: Rome, Vienna, Istanbul, and Amsterdam. Separating the reconstituted capitals are views of them that she appropriated from old etchings, fragments of her earlier lithographs, and images from books about the conquered peoples in the various empires. "I cut up tiny pieces of paper and encrusted the streets with faux mosaic, inspired by the luminous glass mosaics in Rome's early Christian churches," she says.

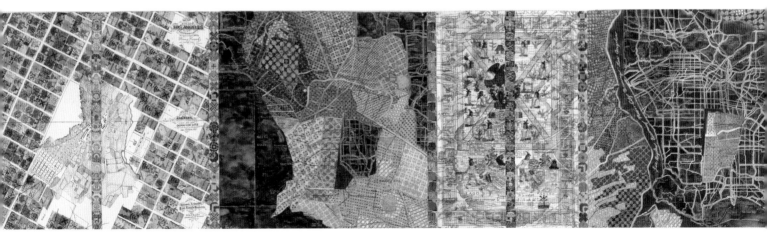

Los Angeles Becoming Mexico City Becoming Los Angeles, 1993

Tofu

photos courtesy of the artist

Tofu is a San Francisco–based artist working primarily in mixed media, collage, and landscape painting. In recent years his work has included postcard-themed art as well as mail art projects. Since 1997 his work has been shown in more than forty venues, primarily in California but also in other locations in the United States and abroad.

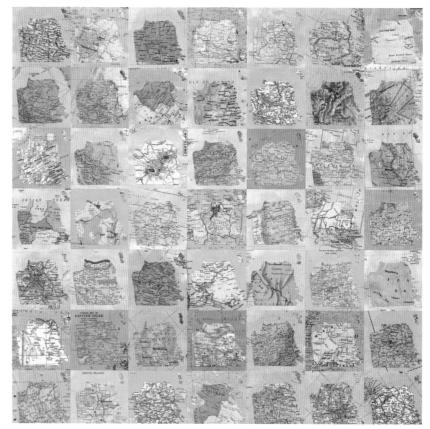

SF 49

Map and Guide

Liz Collins

photo courtesy of the artist

"Old maps have become a fascination for me," California mixed-media artist Liz Collins explains. "Partly I want to save them from rotting away in library drawers, but I also want people to remember them and cherish them before they become obsolete. As a world traveler since childhood, I have developed a fascination for maps that has led me to recognize the map as an art medium in and of itself. Sometimes I think of the map as the "brush." Maps—those intricate patterns of roads and names—give us a place to land, to root ourselves. Placing them in my work, I feel, creates a sense of ease. My art reflects my travels and spans the globe, from my own backyard to far corners of the world."

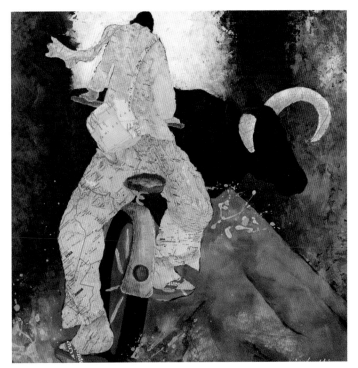

Right of Way

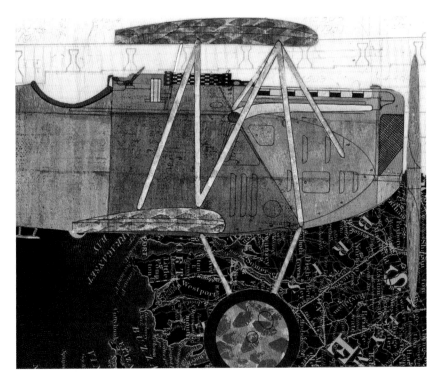

Taking Flight

Mary Ann Gradisher

"My art life began after retiring from teaching and the death of my husband," says artist Mary Ann Gradisher. "I have had no formal art school training, but I have taken numerous workshops and seminars with wonderful supportive artists who have encouraged and guided me. I began with recycled art and have moved toward collage, assemblage, and mixed media. I enjoy putting disparate pieces together to create meaningful and pleasurable art. *Taking Flight* was inspired by my grandson's passion for planes and maps."

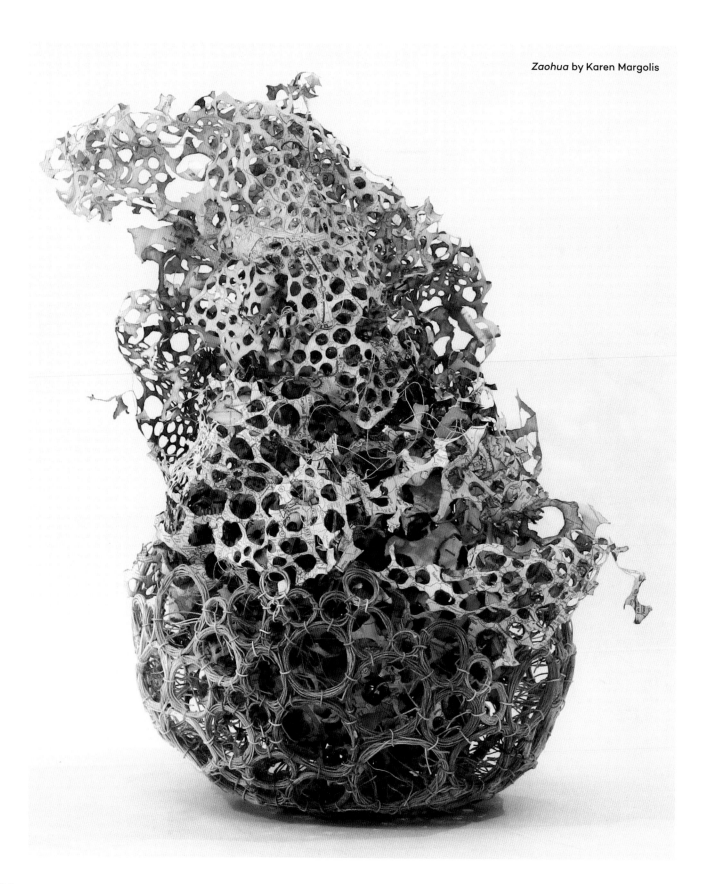

SCULPTURE AND INSTALLATIONS

No matter what you do to maps, they never seem to lose their integrity or charm. Cut them, carve them, combine them with other materials, turn them into sculpture—they still come through and speak to us as maps. In the process, they add dimension and a bit of a backstory to the mediums and materials we use with them. Just looking at maps begins a process of thinking that can quickly turn three-dimensional.

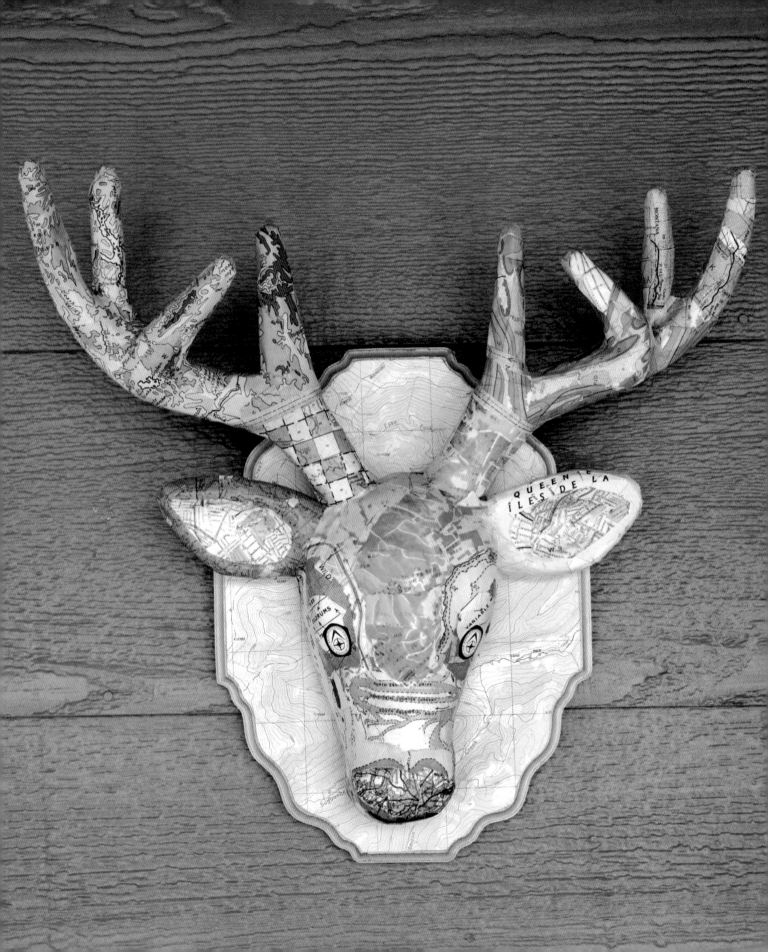

TROPHY HEAD

There are a surprising number of wall-trophy kits and papier-mâché animals available and ready to decorate. I found this one at a local craft store.

TOOLS AND MATERIALS

• map scraps
• scissors
• paper mâché animal head
• matte gel medium
• brush for medium

1 Look over your pieces of map to find details that match the features you want to create on your animal. I found this "eye" shape on one map, and the contour line of the eye on another.

2 Cut or tear the pieces as desired. Tearing the shapes gives them a more organic look. Add humor to your piece by using interesting words from the maps. This one includes "Wild" and "Doldrums."

3 Find design features in the map that work. The equatorial lines fit just across the bridge of this deer's wide nose. The orange curved lines were perfect to suggest nostrils.

4 Use variations in color and pattern to add interest.

5 Brush matte gel medium onto each piece of map and set it in place on the papier-mâché animal head. If you don't like its placement, you'll have plenty of time to lift it and adjust its position. Smooth the overlapping edges. Allow your trophy to dry thoroughly.

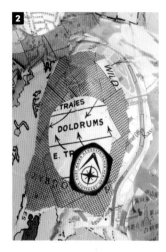

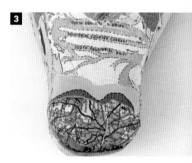

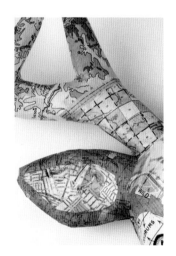

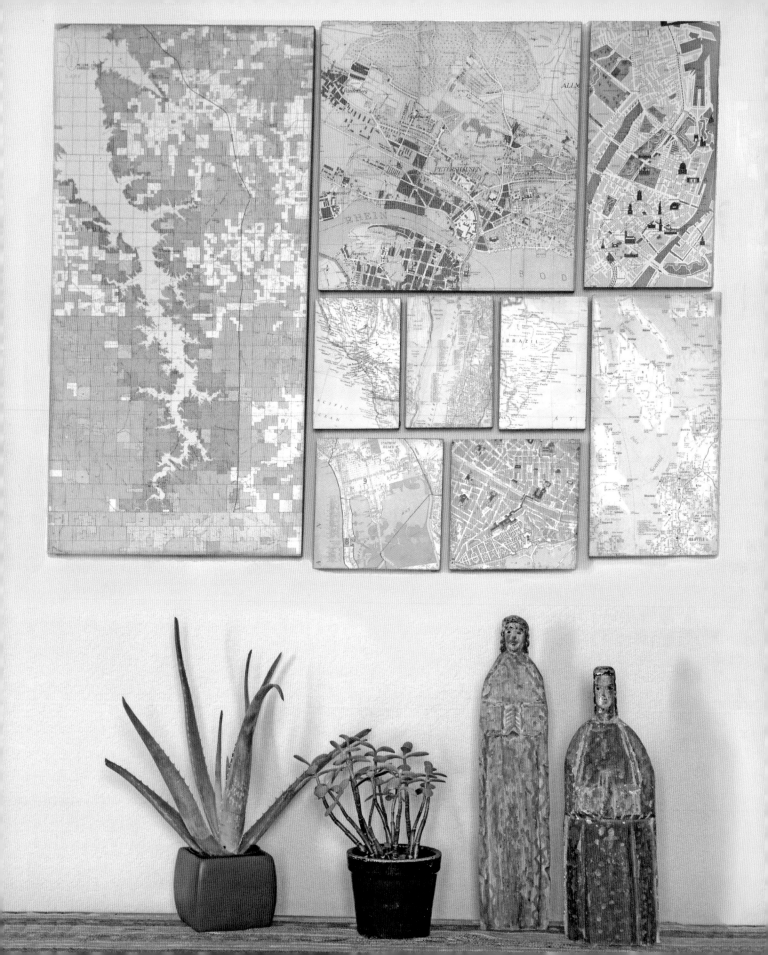

WALL MAP GALLERY

I grew up on the coast and now live landlocked in the Rocky Mountains, so I have a powerful longing for water. I collected maps featuring water and made myself a Wall Map Gallery, mounted on wooden boards. Perhaps it will inspire a reflection wall of your own.

TOOLS AND MATERIALS

- maps
- wood panels of various sizes
- metal ruler and craft knife
- acrylic paint
- paint brushes
- white glue adhesive of choice
- brush for adhesive
- burnishing tool, such as a credit card or hotel card
- bone folder or tool for burnishing
- stamp pad of brown ink
- spray or liquid matte varnish

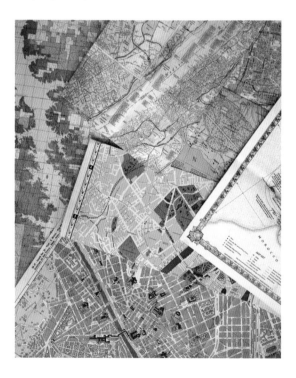

1 Choose a theme and collect the appropriate maps.

2 Make a sketch of your wall arrangement and determine the sizes of the boards to fit the maps you have. Purchase or cut wood panels of the appropriate size.

3 Cut the maps to fit the boards using the metal ruler and craft knife.

4 Paint the edges and sides of the panels.

5 Glue the maps to the panels. Burnish the maps down a few times while they are drying so they glue flat. Cover the map with a piece of paper to protect it when you do this.

6 Antique the edge of the panels with a light coat of brown ink from the inkpad. Let dry, then varnish with matte spray or liquid.

SCULPTURE GALLERY

Brian Dettmer

photos courtesy of the artist

"Through meticulous excavation, I dissect communicative objects such as books, maps, tapes, and other media," says New York–based artist Brian Dettmer. "The medium's role transforms. Its content is recontextualized and new meanings or interpretations emerge. The age of information in physical form is waning. As intangible routes thrive with quicker fluidity, material and history are being lost, slipping and eroding into the ether. Newer media swiftly flips forms, unrestricted by the weight of material and the responsibility of history."

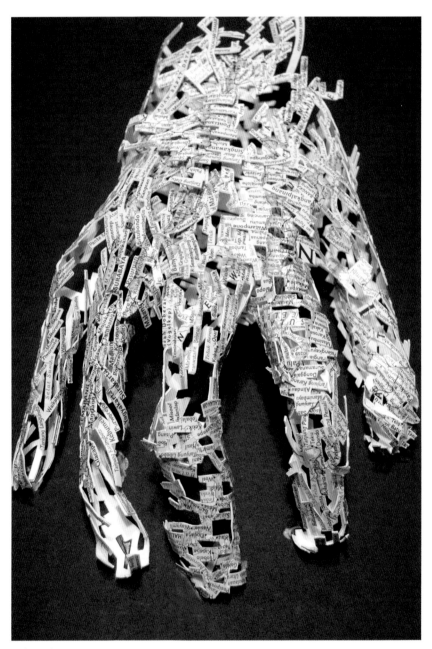

Indonesia

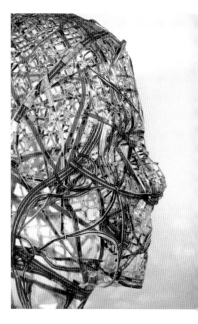

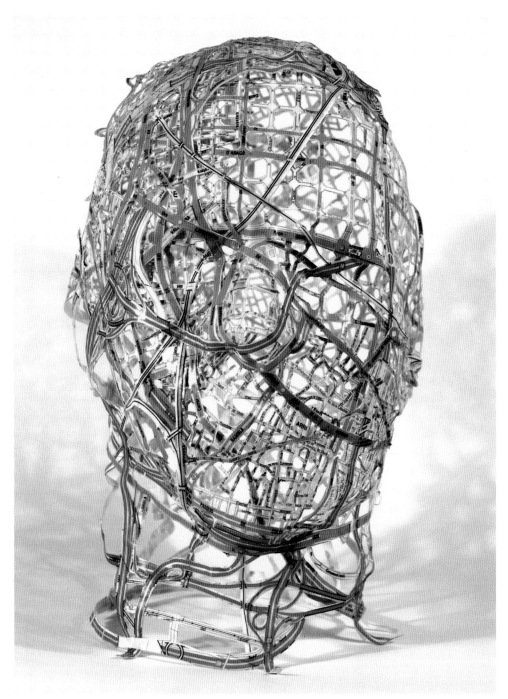

Travel Plans

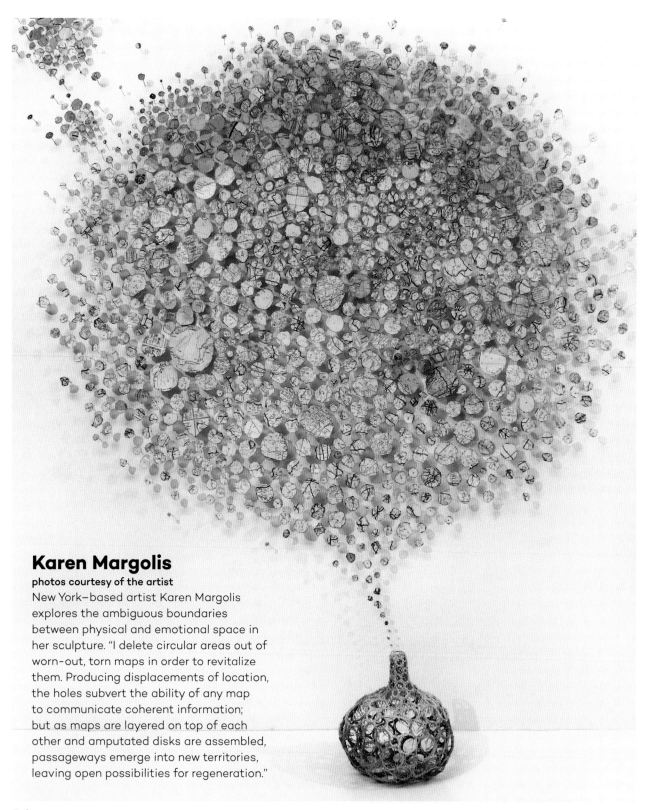

Karen Margolis

photos courtesy of the artist

New York–based artist Karen Margolis explores the ambiguous boundaries between physical and emotional space in her sculpture. "I delete circular areas out of worn-out, torn maps in order to revitalize them. Producing displacements of location, the holes subvert the ability of any map to communicate coherent information; but as maps are layered on top of each other and amputated disks are assembled, passageways emerge into new territories, leaving open possibilities for regeneration."

Baburu

Invalid

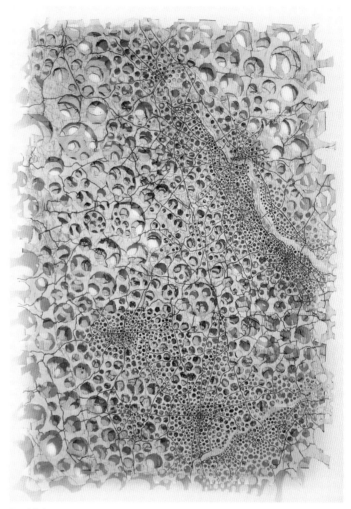

Bethlehem

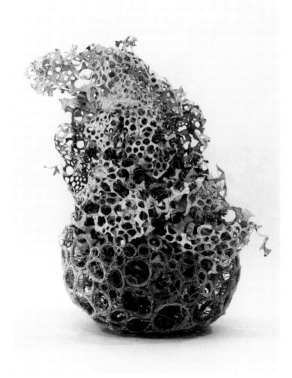

Zaohua

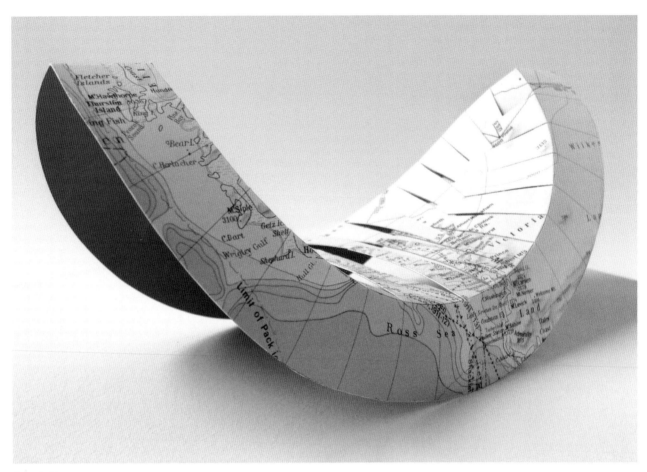

Adaptation

Shannon Rankin

photos courtesy of the artist

From her studio in Maine, Shannon Rankin writes, "I create installations, collages, drawings, and sculptures that use the language of maps to explore the connections among geological and biological processes, patterns in nature, geometry, and anatomy. Using a variety of distinct styles I intricately cut, score, wrinkle, layer, fold, paint, and pin maps to produce revised versions that often become more like the terrains they represent. These new geographies explore notions of place, perception, and experience, suggesting the potential for a broader landscape and inviting viewers to examine their relationships with each other and the world we share."

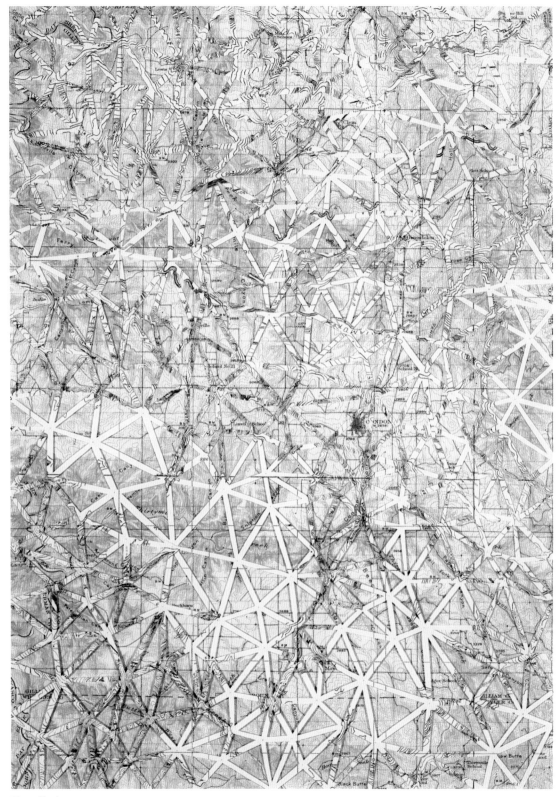

Tessellation

Claire Brewster

photos courtesy of the artist

"It was artists such as Robert Rauschenberg, Kurt Schwitters, and Joseph Cornell who inspired me to experiment with found and unconventional materials," says Londoner Claire Brewster. "I use old and out-of-date maps and atlases as the fabric from which I cut out intricate, delicate, and detailed sculptures. My work is about retrieving the discarded, celebrating the unwanted, and giving new life to the obsolete. The piece *Can't See the Wood* is inspired by the idea of owls getting together and protecting the forest from harm. The silent power and beauty of owls is very inspiring to me. I love to capture them hovering, looking, and watching, always ready to take action."

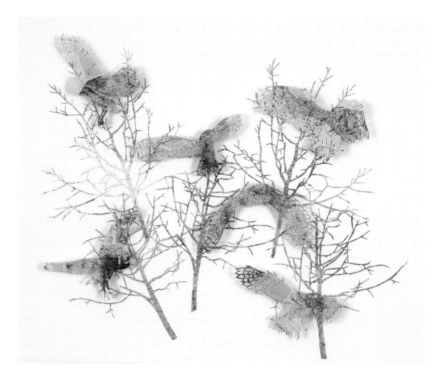

Can't See the Wood

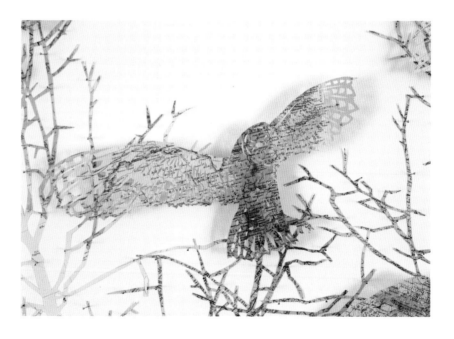

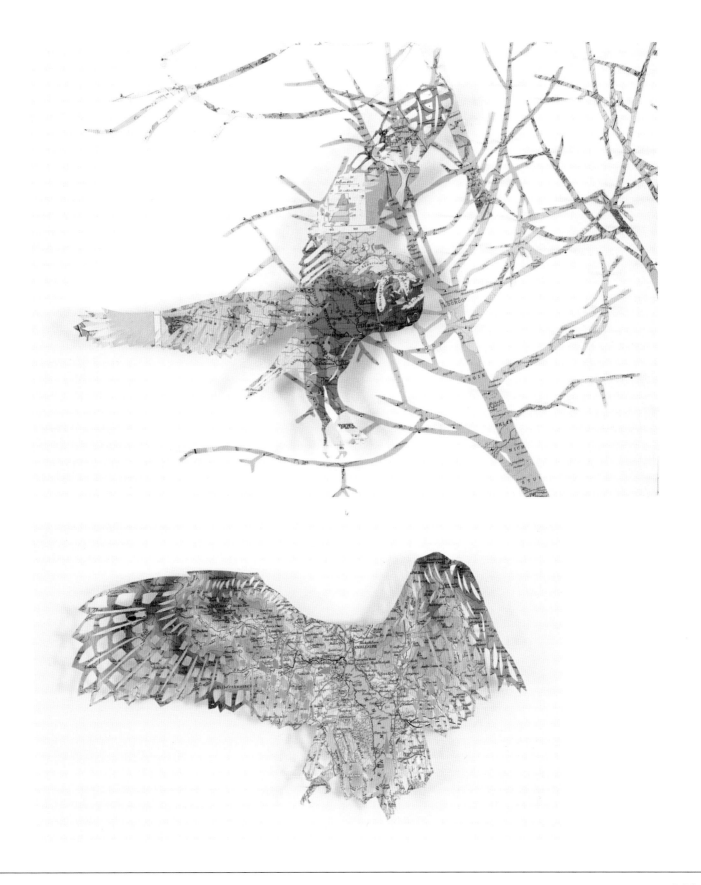

Emma Johnson

photos courtesy of the artist

Reconstructing maps and other paper ephemera into artworks, British artist Emma Johnson cuts paths and multiple layers to transform the originals into reconstituted and complex new objects. As functional items, they are rendered virtually unreadable, but symbolically they suggest evocative personal journeys both geographical and artistic. *Axis* and *Hemispheres* (positive and negative) are two such multilayered images cut from globe projections found in old school atlases.

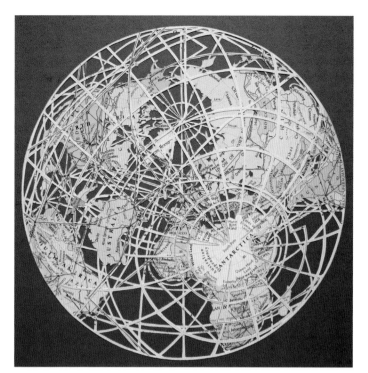

Axis

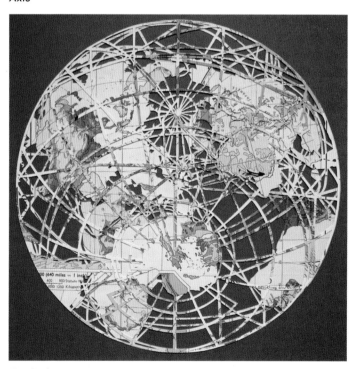

Hemispheres

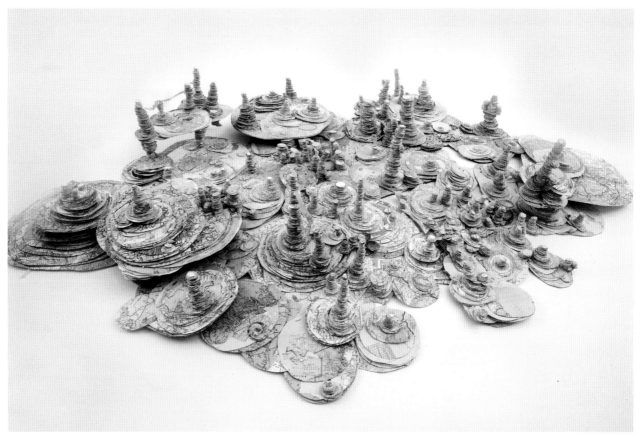

Fracked World

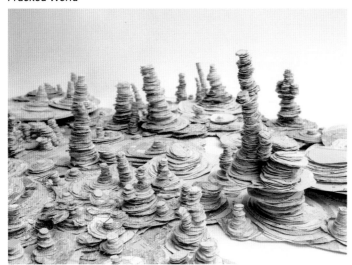

Fracked World detail

Rebecca Riley
photos courtesy of the artist

Rebecca Riley grew up in Colorado but now lives in Brooklyn, New York. Her map pieces developed out of her earlier work exploring the evolving structures and patterns of dynamic systems, from the molecular to the cosmic. Maps depict the dynamic system that is the impact of human settlement on the earth. Increasingly, Riley saw the patterns of development marked out on the maps she was using not simply as fascinating visual systems but as a depiction of the wounds we are inflicting on the earth. Ultimately, these observations led her to her *Fracked World* installations, which, using collaged maps from around the world, depict how the earth might look when it has been scoured and hollowed out by the dynamic system that constitutes humanity's endless quest for resources.

Mary C. Nasser

photos courtesy of the artist

Mary C. Nasser is an artist and art educator living in the greater St. Louis area. She says, "I delight in creating mixed-media paintings layered with maps. I find inspiration in the vintage atlases I collect, and I'm fascinated by the antiquated pages and the ideas of time and travel they contain. For this sculpture, I deconstructed St. Louis area maps, cutting them into hundreds of mosaic-like pieces. As I created the piece, I thought about my own rescue dogs and the immeasurable amount of unconditional love they've given to me. This sculpture is a tribute to them and the special relationship between all people and animals."

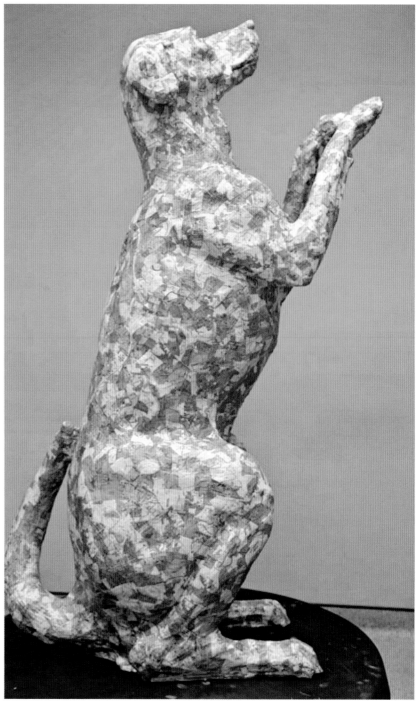

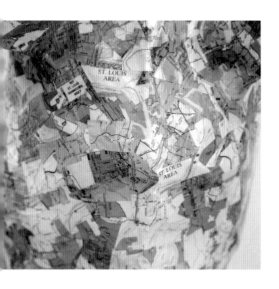

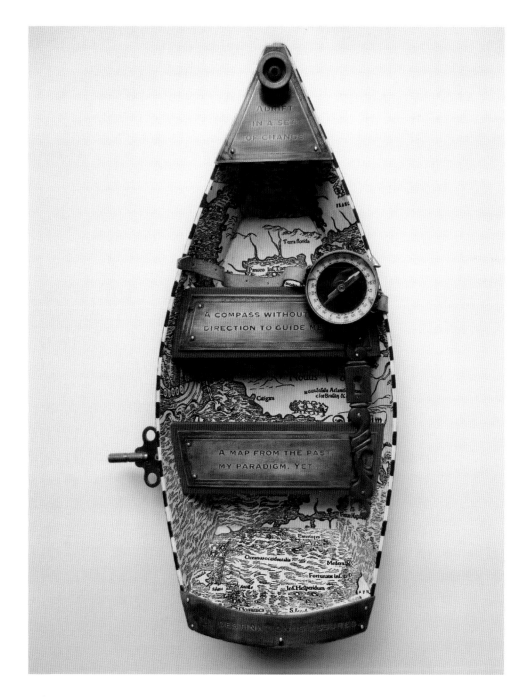

Kim Rae Nugent

photos courtesy of the artist

Kim is a mixed-media artist and author in Wisconsin. With an antique map for inspiration, she created a poem and assemblage.

Adrift in a sea of change,
A compass without direction to guide me,
A map from the past, my paradigm,
Yet, my destination is assured.

Elizabeth Duffy

photos courtesy of the artist

"I use maps of some of the places I have lived in and traveled," says artist Elizabeth Duffy. "I cut the maps by hand, traveling down their roads visually, removing everything in between, and then layer and mount them. The drawings become an archive of places traveled, but the layering tells of the obscuring of memory over time. These works, though not identifiable as particular places, evoke the idea of home for me: something familiar yet foreign."

Elizabeth lives and works in Rhode Island and teaches art at Roger Williams University.

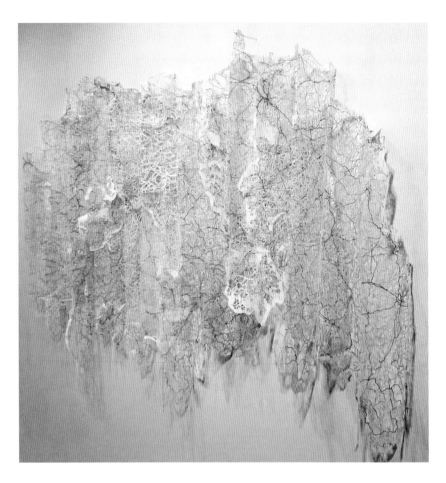

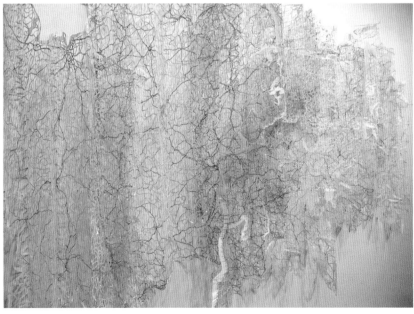

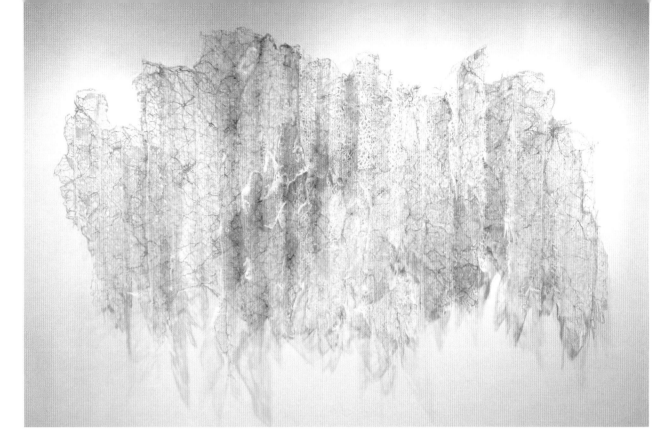

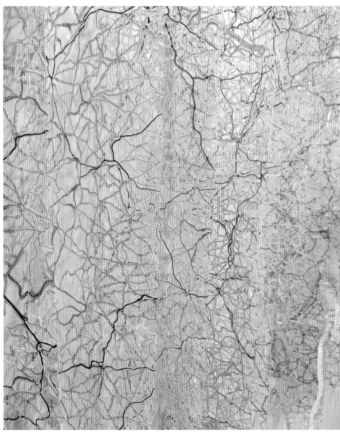

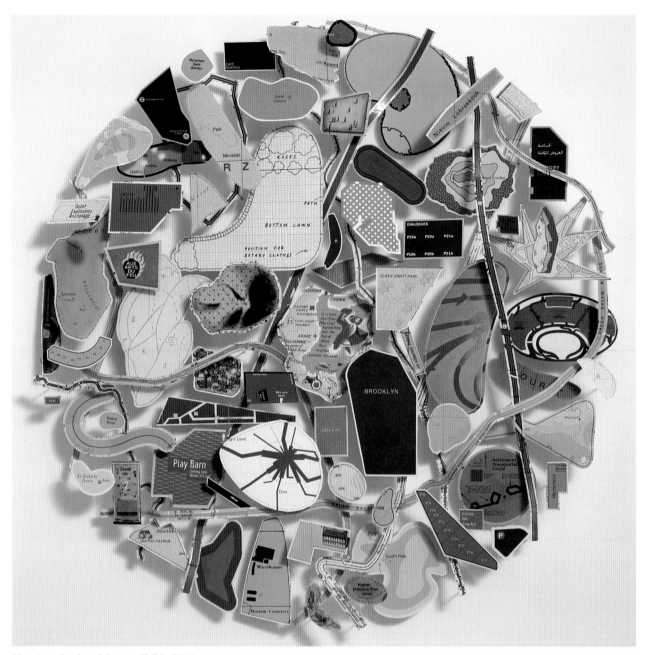

Finn MacCoul and Queen Sirikit, 2014

Chris Kenny

© Chris Kenny, courtesy England & Co Gallery, London.

Chris Kenny's works celebrate the different symbolic vocabularies of maps—unconsciously decorative, colorful schemes that give us geological, political, statistical, or pedestrian information, the graphic languages jostling for superiority and each proclaiming the significance of one little patch of the earth. All the map fragments are original and come from around the globe. The title *Finn MacCoul and Queen Sirikit* refers to two central map fragments: Lough Neagh in Ireland, supposedly created by the mythical giant, and a botanical garden in Bangkok named after the Thai royal.

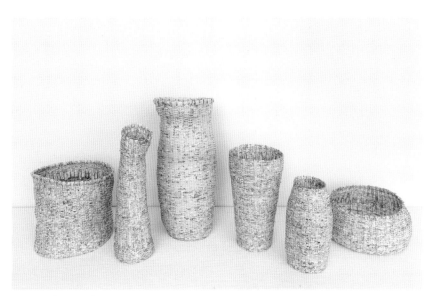

Un Monde en Soi

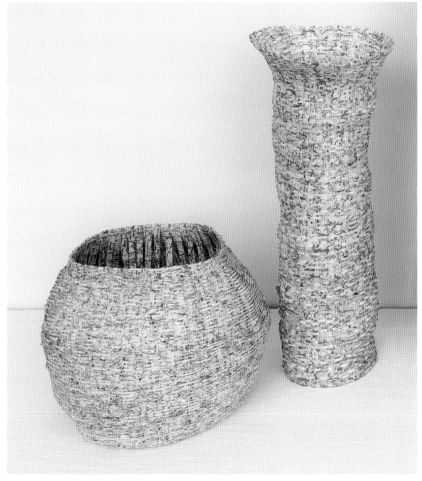

Etienne Frossard

Viviane Rombaldi Seppey

photos courtesy of the artist

Born in Switzerland, Viviane Rombaldi Seppey studied in Australia and Singapore and currently lives and works in New York. "My work is informed by my nomadism between countries, languages, and ways of seeing or thinking," Seppey explains. "This immersion in various cultures has nourished my creative process. Maps are a source material that physically and culturally reflect my own transplantation and describe the elusive meanings of places. My process is characterized by various techniques: I cut, glue, fold, knit, paint, and weave in order to intertwine physical, cultural, and personal territories. My *Un Monde en Soi* series of vessels are symbolic of the way individuals weave a social fabric in order to belong."

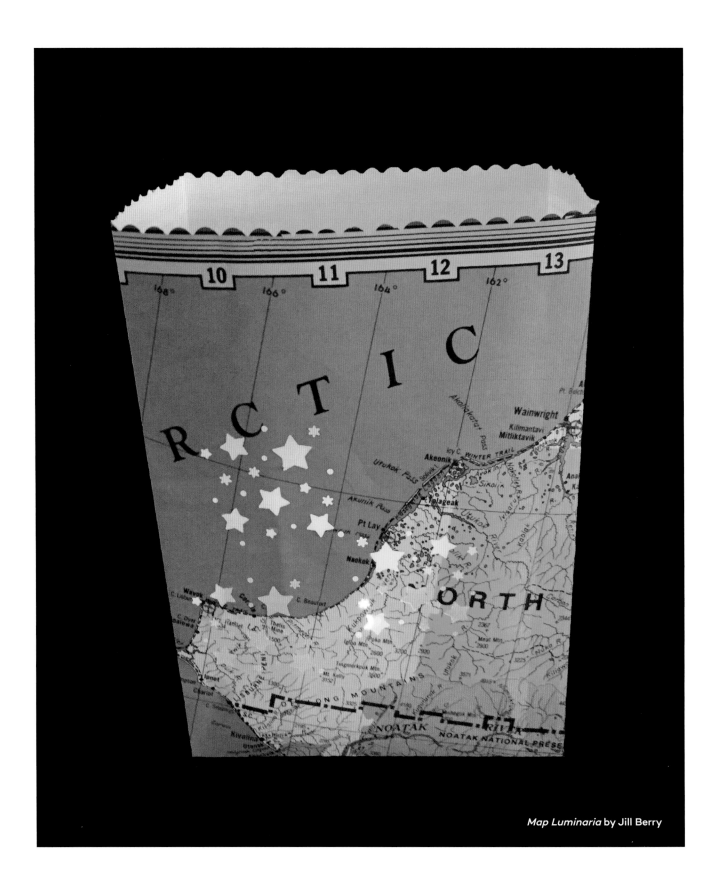

Map Luminaria by Jill Berry

INTERIORS AND LIGHTING

We all know that maps are beautiful by daylight. It turns out they are spectacular at night, too. You'll find several ideas here, including map luminaria, a window shade, and a hanging globe lamp. And why stop with lighting if you're decorating with maps? Maps bring color, warmth, and interest to every room in the house, whether covering a window or adorning a flight of stairs. Surround yourself with your favorite places by way of the sumptuous graphics of a map.

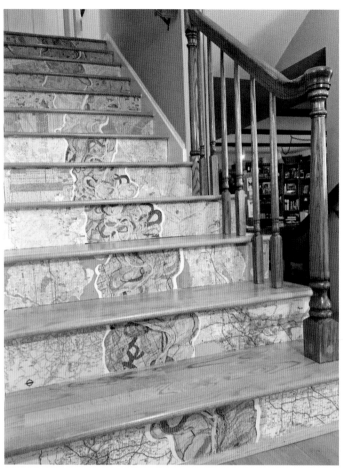
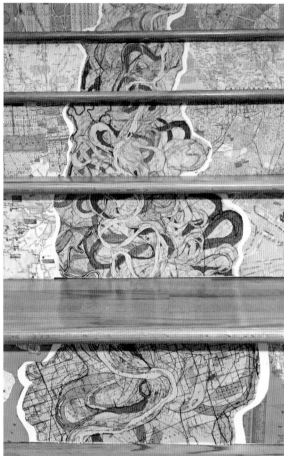

FLIGHT OF FANCY MAP STAIRS

These stairs were white painted wood, a perfect surface for collage. The client picked twelve cities important to her and I searched for maps of those cities. She also loves Mark Twain, so I placed his beloved Mississippi River flowing down the middle of the cities, pulling all those stories and memories together.

TOOLS AND MATERIALS

- maps
- measuring tape
- metal yardstick and craft knife
- matte adhesive
- adhesive brush
- matte varnish
- varnish brush

1 Make a list of your desired maps. See "Map Resources" on page 152.

2 Measure the risers of the stairs. Using a metal yardstick and a craft knife, cut out the maps to fit.

3 Glue the maps in place with matte adhesive.

4 Coat the maps with matte varnish.

CARTOGRAPHIC ROLLER SHADE

Cover your window with a map of Colorado, China, or the South Pacific! This roller shade not only enhances the window, but having light filtered through all the colors and textures of a map adds another dimension to the room.

TOOLS AND MATERIALS

- purchased roller shade
- large map or pieces of maps
- scissors
- strong spray adhesive
- credit card or brayer
- matte finish
- brush for finish
- glue or nails for wood trim
- wood trim for bottom

1 Purchase a roller shade cut to the size to fit your window.

2 Lay out large pieces of map on top of the shade to compose your design.

3 Spray the roller shade and the back of the maps with the adhesive.

4 Carefully lay the map pieces on the shade, with the adhesive sides together. You can trim the edges later. Use the brayer or credit card to smooth out wrinkles or bubbles. Allow the adhesive to dry.

5 Brush on matte finish to make the map more durable, especially if it will be near moisture.

6 Attach the wood trim with glue or small nails.

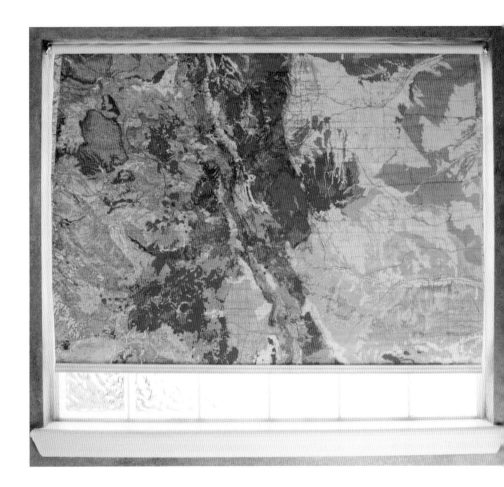

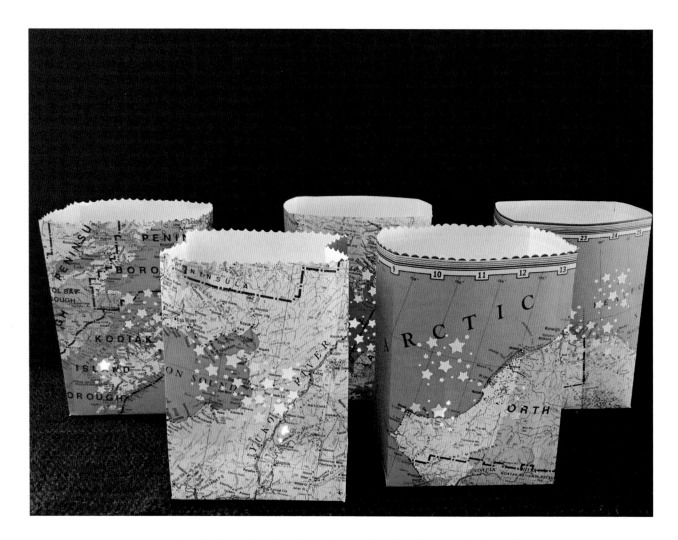

MAP LUMINARIAS

Luminarias are small paper lanterns that are traditionally used in the southwestern United States during the holiday season to softly light a path at night. They can also be used indoors for party décor.

TOOLS AND MATERIALS

- 1 piece of map paper 16½ x 10 inches (42 x 25.5 cm) for each luminaria
- glue stick
- scissors
- decorative edge scissors (optional)
- LED tea candles
- shaped paper punch: stars, hearts, or other varied shapes
- craft glue
- dry sand to weight the bag (if they are to be used outdoors)

1 Enlarge and print this paper bag template to measure 10 inches (25.5 cm) wide and 16½ inches (42 cm) long.

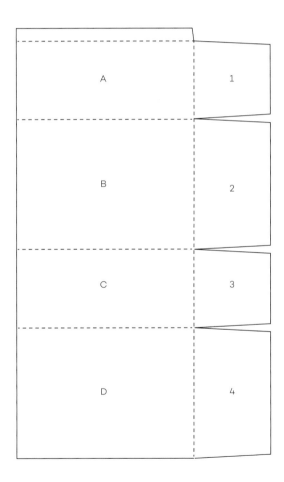

2 Place the template on the map. Trace around the edges, and cut out.

3 Using decorative-edge scissors, if desired, trim the top edge of the bag to add a shaped edge.

4 Score fold lines as indicated by the dashed lines on the template.

5 Punch decorative holes into the front panel of the bag. Punching the holes in the darker areas of the map adds contrast.

6 Glue the side tab first, lining up the edges carefully.

7 Fold down flap 2 to form the bottom of the bag.

8 Fold down and glue flaps 1 and 3 to flap 2.

9 Fold down and glue flap 4 into place and allow the glue to dry.

10 If you are using the luminaria outdoors, pour 2 inches (5 cm) of dry sand into the bags to weight them.

11 Set LED tea lights inside the bags and get ready for your guests!

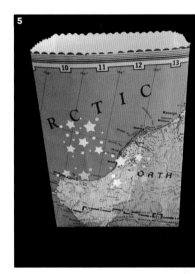

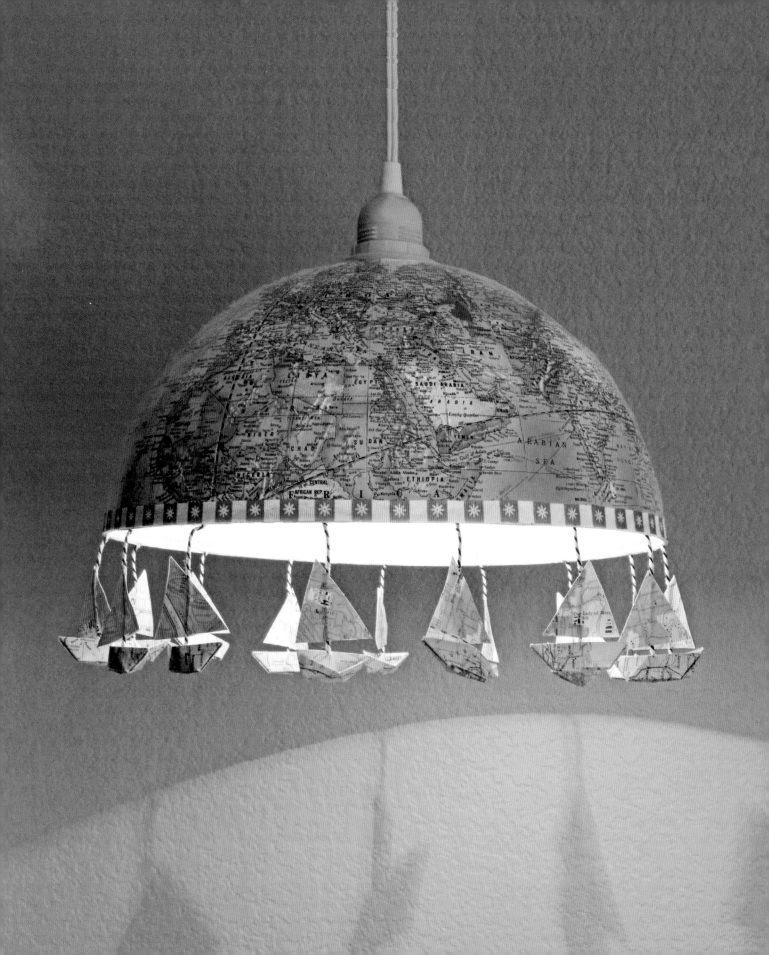

GLOBE SWAG LAMP

Most paper or cardboard globes are made in two parts, joined with a seam around the equator. There is often a small strip of tape holding the two halves together. This is easy to remove. When you do, you have the perfect shade for a swag lamp. Decorate it and you'll have an enchanting piece of custom lighting.

TOOLS AND MATERIALS

- paper-covered cardboard globe
- low-tack masking tape
- electrical hanging cord kit for lanterns
- drill with large bit
- white acrylic paint
- paintbrush
- fringe or edging (optional)
- ribbon, 2x circumference of globe plus extra

1 Find the seam around the middle of the globe and separate the two halves. Set the bottom half aside for another project.

2 Prepare to drill a hole for the cord by covering the center top of the globe with masking tape. Fold the edge of the tape under to make it easier to remove.

3 Check the size of the lamp cord that comes in the hanging cord kit. Drill a hole at the center top of the globe the size of the circular insert on the lamp cord. Make sure it is no bigger or it will not be snug. (Some globes have a round metal washer reinforcement at the axis, both the top and the bottom.)

4 Paint the inside of the globe white so that it reflects light optimally.

5 Add edging if you like to finish it off both on the outside and on the inside bottom. Mine is length of ribbon plus a set of origami boats with sails.

6 Insert the lamp cord as per instructions on the package and hang it up.

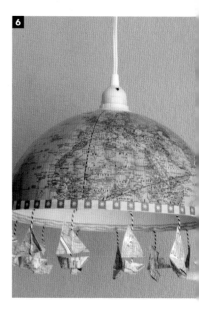

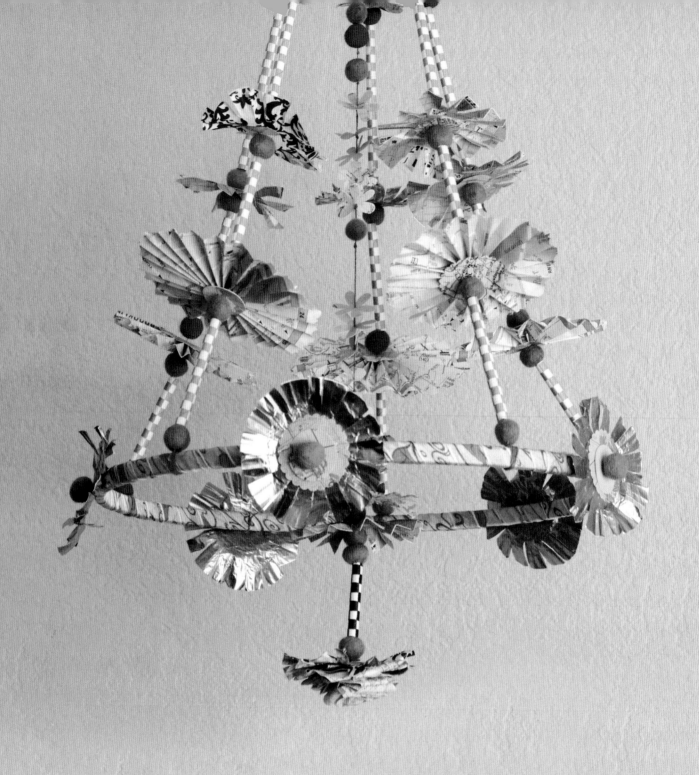

PAJAKI

This project is based on the craft of pajaki: paper chandeliers made by Polish peasants to hang from the ceiling as a part of an elaborate celebration at Christmas. The literal translation of *pajaki* is "spiders of straw." This project is perfect for the map scraps you may have left over from other projects.

TOOLS AND MATERIALS

- 13 paper drinking straws, about 8 inches (20.5 cm) long
- paper punches: large circle, medium circle, and shapes like a flower or a star
- map scraps
- glue
- circle cutter
- decorative-edge scissors (optional)
- 12–inch (30.5 cm) wooden hoop (embroidery hoop)
- 2 yards (1.8 m) of 1 ½–inch (4 cm) wide ribbon
- paper candy cups: metallic or decorative (optional)
- scissors
- unwaxed linen: 3 pieces 2 yards (1.8 m) each, 5 pieces 10 inches (25.5 cm) each
- metal ring hanger, 12 inches (30.5 cm) or more in diameter
- needle
- fifty ½–inch (1.3 cm) pom-poms
- 12 x 16–inch (30.5 x 40.5 cm) piece of map
- 5 binder clips

Make the Elements

1 Cut three straws in half. Cut four into thirds. Leave six straws whole.

2 Cut or punch out three sizes of circles, approximately 1 inch (2.5 cm), 2 inches (5 cm), and 3 inches (7.6 cm). Some of the circles will be glued in sets of two, back-to-back, so they are sturdy and have maps on both sides.

3 Use the small paper punch to punch out 23 small circles. These will sit on top of the other circles and do not have to be double-sided.

4 Use the medium paper punch to punch out 64 medium circles. Glue them back-to-back to make 32 finished circles (13 for the Daisy Flower, 12 for the Accordion Flower, and 7 cupped). Make the 7 cupped circles: while they are wet with glue, bend them to form cupped disks. The other circles can be flat.

5 Use the flower or star punch to make 20 flowers or stars. Glue them back-to-back for 10 finished pieces.

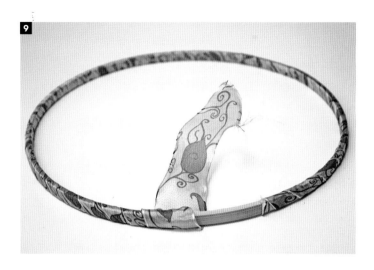

6 Use the circle cutter to cut out 13 large circles. These are about the same size as the candy cups. They will be used to make daisy flowers.

7 Cut 3 strips 4 inches (10 cm) wide and 16 inches (40.5 cm) long. Cut each long side with decorative-edge scissors, if desired. These strips will be cut in half later to make 6 accordion flowers.

8 Make one Rose following the directions in "Foundational Basics," page 13.

9 Wrap the wooden hoop with the ribbon. Glue to secure at the end.

Make the Daisy Flower (make 13)

1 Glue the 3-inch (7.5 cm) large circles and the candy cups back-to-back.

2 Glue a medium 2-inch (5 cm) circle in the center of each 3-inch (7.5 cm) circle. Use it as a guide to cut the petals.

3 With the scissors aimed toward the center of the circle, cut petals, ending the cut at the edge of the medium circle. Add a small 1-inch (2.5 cm) circle on top for another layer.

4 Bend the petals upward while the glue is wet.

5 Make 13 Daisy Flowers with varied colors. I used two-sided metallic cups to make the 5 on the rim.

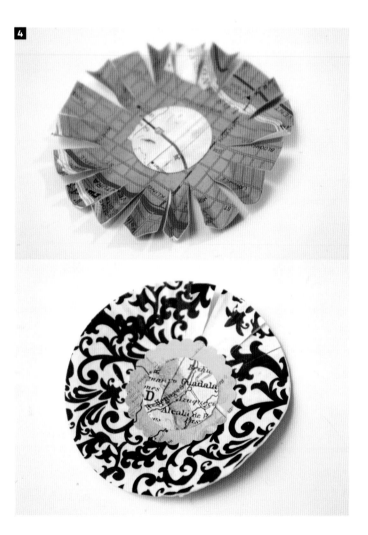

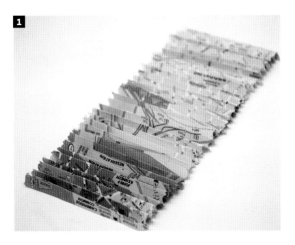

Make the Accordion Flower (make 6)

1 Use the 3 prepared strips from step 7 in "Make the Elements." Fold the strips of paper into a very small accordion fold as shown. The panels should end up about ¼ inch (6 mm) wide or less.

2 Cut the strip in half to make two accordian strips.

3 Glue the ends of each strip together to make a round bracelet shape. Allow the glue to dry.

4 Collapse the circle into the center by pushing the top edge toward the center. The flower shape will start to pop up, so hold it down in the center with your finger.

5 Add glue to the center.

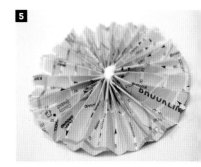

6 Glue a medium 2-inch (5 cm) circle in the center. Turn the flower over and glue another circle in the center. It needs the stability here. Hold the glued circles between your fingers for a minute or so while the glue sets.

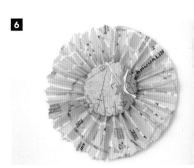

7 Repeat to make six Accordion Flowers.

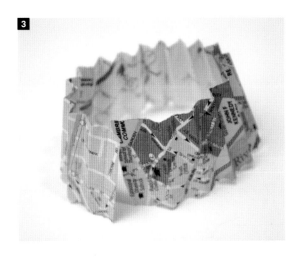

Assemble the Pajaki

The only rule to assembly is that the lengths of straws and flowers have to be even so the hoop hangs evenly. You can change the order of any of these instructions.

1 Fold the long linen thread in half and loop it over the metal ring hanger to tie. Tie all 3 long pieces onto the ring. Five of these will form the sides, and one will hang in the center.

2 Thread the end of one strand through the needle and run it through the center of the elements. This is the pattern I used for threading: full straw, pom-pom, cupped disk, small circle, pom-pom, ½ straw, pom-pom, small circle, Daisy Flower, pom-pom, ⅓ straw, pom-pom, Accordion Flower, pom-pom, ⅓ straw, pom-pom. Tie the thread to the ribbon-wrapped hoop and secure with a binder clip.

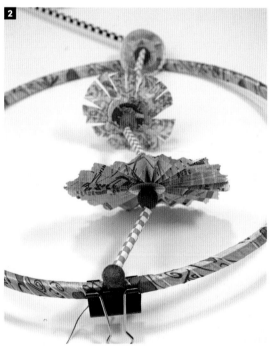

3 Repeat step 2 with all 5 lengths of thread.

4 Adjust all the decorative lengths to make sure the hoop hangs evenly. When you are done, wrap the thread a few times around the hoop, and back through the bottom pom-pom. Knot and trim.

5 The center thread can be decorated any way you like. I used this pattern: full straw, pom-pom, knot, pom-pom, knot, pom-pom, knot, punched flower followed by a knot (repeat 5 times for 5 punched flowers in a row with knot in between), pom-pom, punched flower followed by a knot (repeat 5 times for 5 punched flowers in a row with knot in between), pom-pom, Accordion Flower, pom-pom, 2 disk cups back-to-back, pom-pom, Daisy Flower, 2 pom-poms, Daisy Flower, ½ straw, pom-pom, Daisy Flower, Rose. Go through the middle of the rose from the back, then push the needle back into another space near the front center of the Rose and back through the flower and pom-pom above it. Tie off.

6 Attach the remaining 5 daisy flowers to the outside of the hoop with a 10-inch (25.5 cm) length of thread on the needle. Enter from the back, through the flower, through the bottom half of a pom-pom horizontally, and back through the same hole. Tie it to the hoop with a knot and glue the back of the flower to the hoop to stabilize.

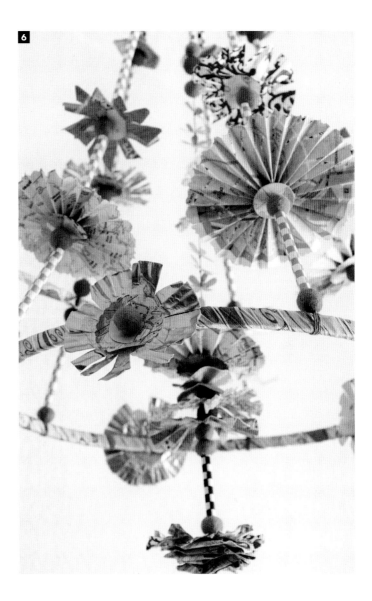

INTERIOR GALLERY

Deedee Hampton

Deedee Hampton is an artist and traveler who works from New Mexico. "Last winter I cheered myself up by creating pajakis to hang in every room," she says. "I decided to incorporate my love of travel into my pajakis by using maps instead of the customary colored papers. Lately, I've been working on a series of pajakis as reliquaries. One is a reliquary for the planet earth. The other two express the wonder of exploration. Two of the pajakis start at the top with celestial maps, then move down into earth elements and finish off with ancient maps of sea monsters and ships, with the third being made from 'netting' created by punching out shapes from the maps. Those shapes dangle from the bottom along with map flowers."

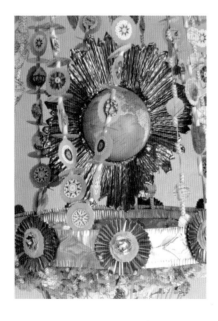

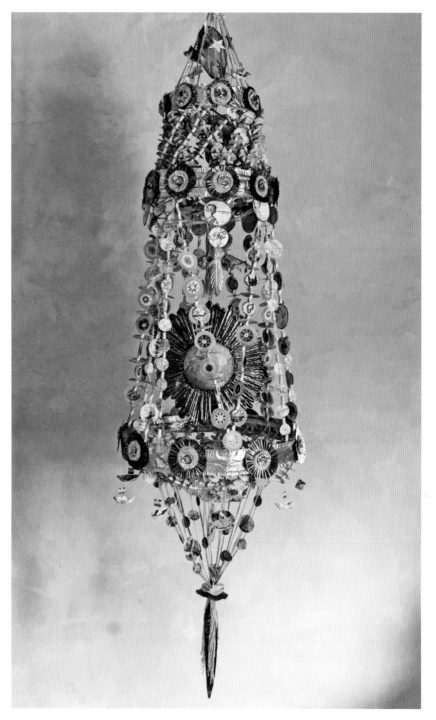

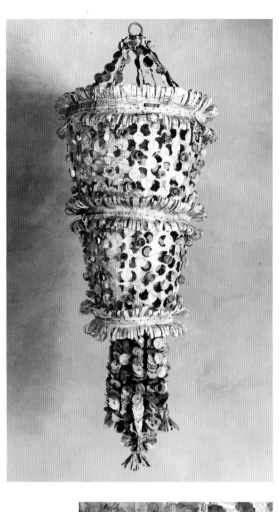

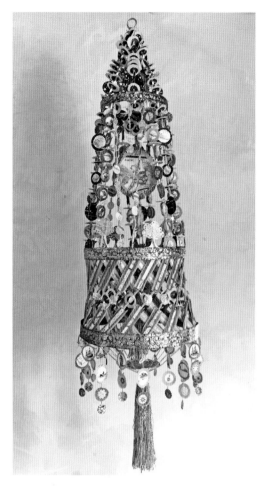

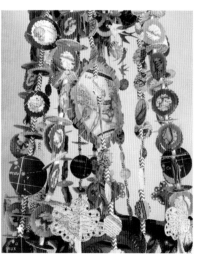

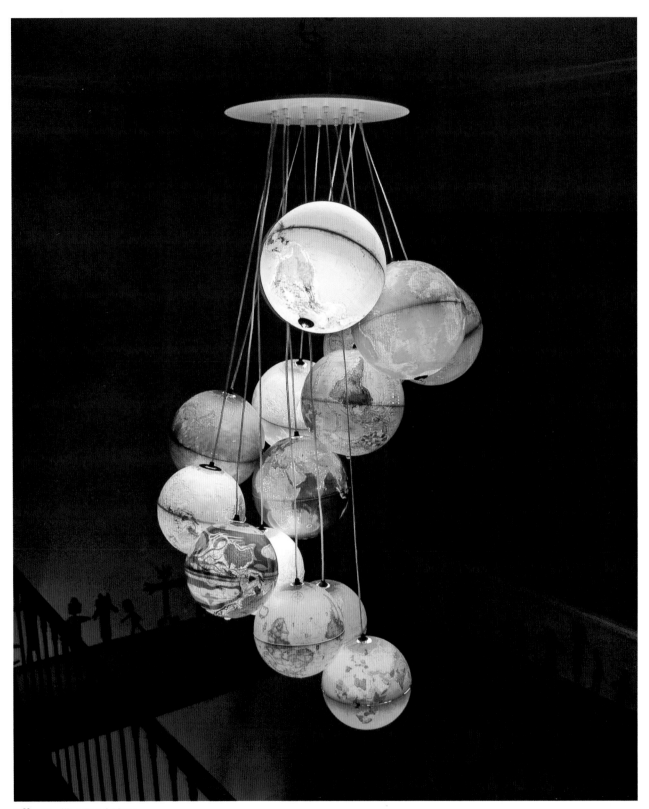

Effet Papillon Fond Blanc

Benoît Vieubled

photos courtesy of the artist

Benoît Vieubled began his career as a teacher of painting and visual arts at the Visual Art Institute in Orléans, France, and taught at colleges in the Centre region of France. Since 1997, he has moved toward the creation of lamps and exceptional objects inspired by his own world: a repository of his personal mythology, treading a fine line between art, sculpture, and decorative objects.

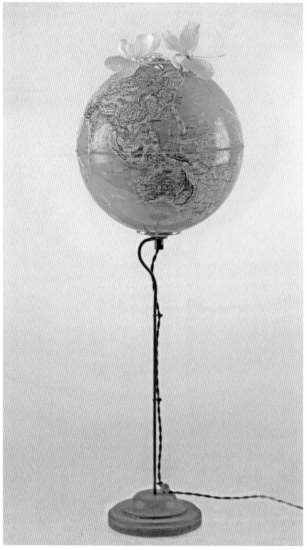

Mappe Mondes

Effet Papillon

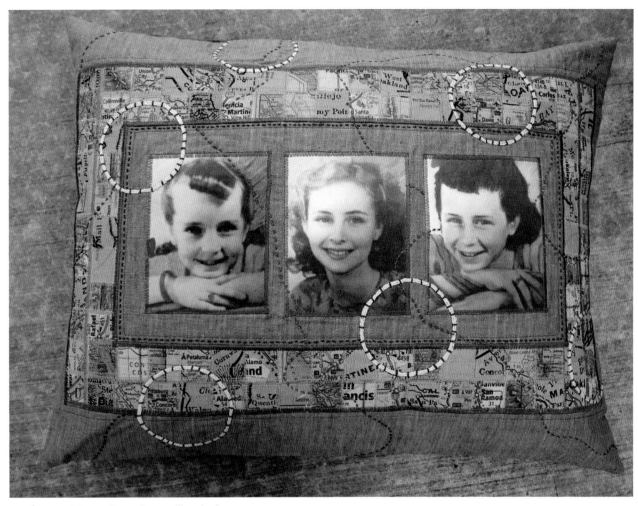

California Girls, **Family Heritage Pillow Series**

Maude May

photos courtesy of the artist

"I've been making art in one form or another since age three," says Maude May from her home in Portland, Oregon. For the past twenty-five years I have specialized in designing custom invitations, favors, and party ephemera for private and corporate clients. I've also re-embraced my sewing roots, creating stitched fiber and paper collages, utilizing cotton and silk threads, handmade papers, maps, and my own photographs and personal rubber stamp images. *California Girls* honors the Shelley girls: Laura, Virginia, and Jeanne. They were born in California and raised in Martinez and the Bay Area in the 1940s. The pillow celebrates the oldest daughter, Virginia, on her recent 85th birthday. These women have lived in many places, both in the United States and abroad, but at heart they are still California girls."

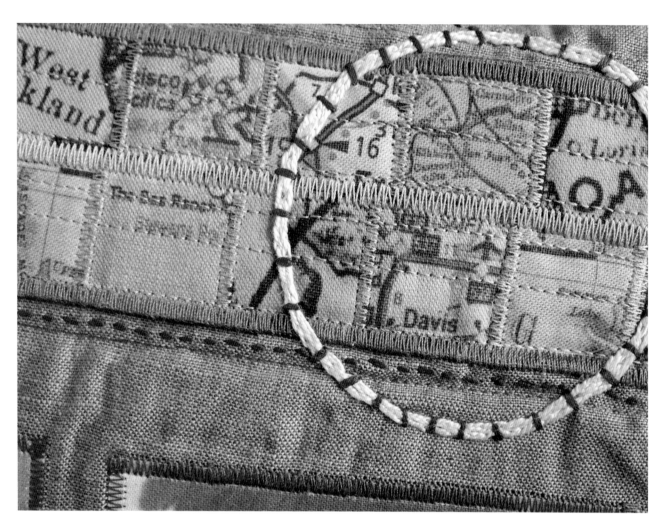

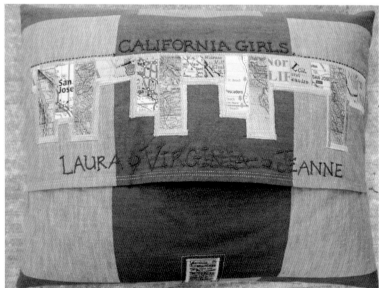

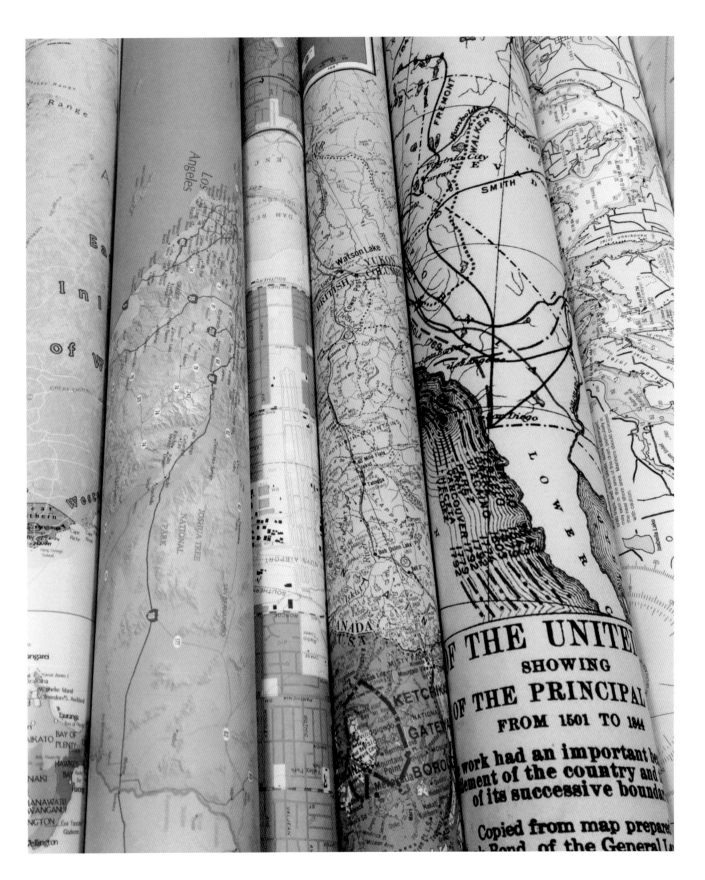

CONCLUSION

WHY ARTISTS LOVE MAPS

Maps are in some ways intended to show us truth about where we are, who is next to us, what that terrain might look like, and how to get where we want to go. When artists crumple, cut, paint over, and otherwise change that source of information, are they reinventing reality? Does the map retain the truth it once held? Does it impart this truth to the new form? The artists in this book illustrate both new territories with old maps and the celebration of a cartographic location in a new form. I asked the contributing artists why they use maps.

Penny Arrowood

"A good deal of my work involves letterforms, word play, and repurposing imagery—maps of any stripe fill each of these needs rather handily. And there are so many types of maps: never-ending inspiration! The use of maps is also an easy way to personalize the story I am telling in any composition (where our family came from, places I have lived, where our children are, places I have dreamt of visiting, and so on). It doesn't matter if no one ever knows it but me. It is easier still to tell another's story—truth or fiction—with bits and pieces and reimaginings of these lovely things: maps!"

Rachel Austin

"I love their quiet beauty and the way they show us where we are, where we are going, and where we have been."

Claire Brewster

"I use maps because I love their poetry and romance. You can travel the world and dream of exotic places when looking at a map. I also love the tactile quality of the paper and the extraordinary print quality of vintage maps."

Lou Cabeen

"I'm drawn to maps for the same reason I'm drawn to using textiles. They are humble, familiar materials that are accessible to many different kinds of people, and like textiles, maps evoke stories."

Matthew Cusick

"Every mark on a map is a representation of an existence and is an index of a specific time, place, and territory. By splicing together diverse map fragments into the matrix of an illusory image, I am able to render hybrid topographies that unveil new relevance from obsolete narratives."

Gwen Diehn

"I just like aerial views—always have. Nothing better than drawing from the window of a plane!"

John Dilnot

"We think of maps as science-based diagrams that describe the terrain for practical applications such as an aid for a journey. But they are much more than that; they are things of aesthetic beauty. While gazing at a map, with no particular purpose, it can be a vehicle for an imaginative journey, perhaps to get lost for a moment while just traveling with the eye. I use old maps in my work; they are a starting point and will indicate a direction of making. I see them as a substitute for a landscape, and while reading them, a picture of a place can be built up in the mind.

"For me, maps have a perfect matter-of-fact quality. They are quiet and unsentimental, a remove from the noisy reality on the ground. Everything looks better from a distance."

Sharon Erlich

"There are two things that attract me to using maps in my necklaces. One, I'm fascinated by the inherent graphic and abstract qualities that I find when I spread out a map and see the tangle of lines, colors, words, and shapes. And when I identify a particularly interesting or beautiful area, I envision how to use those sections to take on new life as a form of wearable art. Many times my necklaces almost make themselves because I'm actually "seeing" a necklace within the lines and shapes. The other thing that attracts me is that the necklaces become not only interesting, wearable pieces of art, but also resonate with the feelings or memories they evoke of places that are special or have meaning to people."

Terry Garrett

"I have always loved maps for their graphic qualities—the colors and lines and shapes—but also what they can represent. They are a way to discover another place—both adventure and guide. Using maps in my art adds these elements to my work."

Salyna Gracie

"Maps provide a perfect contemplation of the inner journey. I am fascinated with maps as a unique guide to a kind of internal navigation: deciphering the lost key, or legend, to unlock the map of my destiny, guided by the compass rose of my heart, to find my own personal truth."

Liz Hamman

"I like to use maps as an artistic medium because they represent certain values that mean so much to me: the value of the journey in addition to the destination, the value of our ancestors, family, and history, the memories of the places we have traveled to and anticipation of journeys yet to embark upon, the value of nature and the landscape. I also love the way they are folded: it's a type of origami. Most of my jewelry, made with maps, uses valley and mountain folds, which reflect back to an aspect of what maps depict."

Deedee Hampton

"I am always looking for the best—the most loving, most enlightened, most beautiful, most present, most stimulating, most satisfactory—path to help me find my way through life. Maps give us direction. Sometimes we stay on that path and sometimes we choose to get lost because it looks more interesting."

Emma Johnson

"Roads, rivers, and pathways: a network of veins and arteries, the lifeblood of our planet. Follow them and see where they take you."

Brian Kasstle

"I have been drawn to maps from the time I was a child. I always loved the maps in old *National Geographic* magazines and maps when we took trips when I was a child. I have been told much of my artwork reminds folks of topographic maps. What I love most about maps is the history and the sense of mystery and adventure they have."

Joyce Kozloff

"Maps for me are a vehicle into which I can layer content. I think of them like the scaffolding of a building, and I came to mapmaking through public art, where I was always building upon an architectural structure."

Rosalba Lucero

"I find such beauty in maps because of their colors, lines, and design that using them as an artistic medium is an easy choice, especially if the map you are using has a special significance to you because it's from a special place you have been."

Thomas LaBadia

"What I am most attracted to with using maps is that they are so random. When I work with maps, I see so many beautiful shapes and interesting variations of line and color. This excites me and takes me to places I could not have imagined on my own. Plus, they give me the feeling of history, which I also love."

Joao Machado

"Everybody needs a map to understand the physical world we live in. We look to maps to understand the spiritual world, as in astrology, for example. We need maps to understand each other in this constant exploration—an exploration of both the extent of the galaxy and the depths of our own inner space."

Karen Margolis

"I'm attracted to maps because with their vascular systems and arteries they act as proxies for our physical selves. In addition, we look to maps to provide us with answers: they give an implicit promise of direction, and yet, like humans, they grow old and obsolete; they degenerate and lose their ability to meet our needs."

Mary Nasser

"I am captivated by the way maps look—their lines, rhythm, movement, and patterns. I find inspiration in vintage atlases I collect, as I am fascinated by the antiquated pages and the ideas of time and travel they contain. Maps and cartographic elements are repeating motifs in my work because I love both the concept and the imagery of maps."

Martin O'Neill

"The insane detail."

Shannon Rankin

"Maps are the everyday metaphors that speak to the fragile and transitory state of our lives and our surroundings. Rivers shift their course, glaciers melt, volcanoes erupt, and boundaries change both physically and politically. The only true constant is change."

Rebecca Riley

"The aesthetics of a map —the linear structure and the patterns that build upon that structure—attract me, both in the way they show how people have manipulated the earth, as well as in the way a topographical map shows the patterns in the earth itself."

Viviane Rombaldi Seppey

"Maps are for me a symbolic material to describe the elusive meanings of places and my relation to them."

Julia Strand

"Given that my art requires making use of existing illustrations, maps are appealing because they include precise, fine details and crisp edges."

Tofu

"The impermanence of the information on maps fascinates me. Names change, borders move, small towns disappear or get swallowed up by bigger towns, small towns become cities in a matter of a decade or two. And even the physical features are not permanent. Rivers dry up, coasts erode, volcanoes blow their tops. When I use an out-of-date map in a work of art, I am taking that former reality and giving it a permanent place in time."

MAP RESOURCES

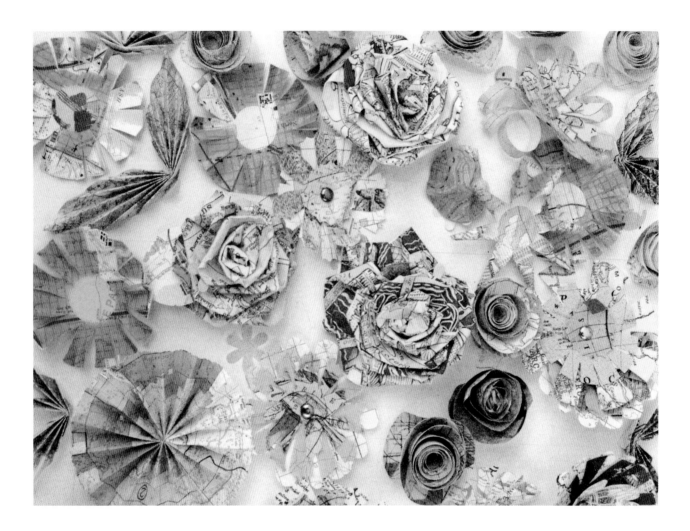

Digital Maps

American Geographical Society
www.uwm.edu/libraries/agsl

Biblioteca Nacional de España
www.bne.es/en/Colecciones/
GeografiaMapas

British Library
www.bl.uk/subjects/maps

Harvard University Map Collection
hcl.harvard.edu/libraries/maps/
digitalmaps

**Huntington Library Digital
Map Collection**
hdl.huntington.org

Japanese Historical Maps
vm136.lib.berkeley.edu/EART/
browse.html

Library of Congress Maps
www.loc.gov/maps

Mississippi Meander Maps
lmvmapping.erdc.usace.army.mil/
index.htm

National Library of Australia
www.nla.gov.au/what-we-collect/
maps

Nautical Charts
www.nauticalcharts.noaa.gov/
pdfcharts

New York Public Library
www.nypl.org/node/80186

Planetary Maps
www.lpi.usra.edu/resources/
mapcatalog/usgs/index.shtml

Prints of Old Maps
www.davidrumsey.com
www.antiquehistoricalmaps.com

**University of California,
Santa Cruz, Library**
digitalcollections.ucsc.edu/
cdm/landingpage/collection/
p15130coll3

University of Chicago Library
www.lib.uchicago.edu/e/
collections/maps

University of Texas at Austin
www.lib.utexas.edu/maps/
world.html

USGS Topographical Maps
ngmdb.usgs.gov/maps/TopoView

Map Stores
Boulder Map Gallery, Boulder, CO:
www.bouldermapgallery.com

Metsker Maps, Seattle, WA:
www.metskers.com

Stanfords Map Gallery,
London and Bristol, UK:
www.stanfords.co.uk

Other Resources
Map History
www.maphistory.info

Atlas Obscura
www.atlasobscura.com

Map Templates and Projects
www.3dgeography.co.uk

Books About Maps
Berry, Jill K.
*Personal Geographies:
Explorations in Mixed-Media
Mapmaking.*
North Light Books, 2011

Berry, Jill K. and Linden McNeilly.
*Map Art Lab: 52 Exciting Art
Explorations in Mapmaking,
Imagination, and Travel.*
Quarry Books, 2014

Brotton, Jerry.
Great Maps.
DK Smithsonian, 2014

Goodwin, Valerie S.
*Art Quilt Maps: Capture a Sense
of Place with Fiber Collage.*
C&T Publishing, 2013

Harmon, Katherine.
*You Are Here: Personal
Geographies and Other
Maps of the Imagination.*
Princeton Architectural Press,
2003

Harmon, Katherine and
Gayle Clemans.
*The Map as Art: Contemporary
Artists Explore Cartography.*
Princeton Architectural
Press, 2010

Harvey, Miles.
*The Island of Lost Maps: A True
Story of Cartographic Crime.*
Broadway Books, 2010

Holmes, Nigel.
Pictoral Maps.
Watson-Guptill Publications, 1991

Nigg, Joseph.
*Sea Monsters: A Voyage Around
the World's Most Beguiling Map.*
University of Chicago Press, 2013

Turchi, Peter.
*Maps of the Imagination:
The Writer as Cartographer.*
Trinity University Press, 2007

Van Duzer, Chet.
*Sea Monsters on Medieval
and Renaissance Maps.*
British Library Publishing, 2014

CONTRIBUTING ARTISTS

Anderson, Susan
Colorado, USA

Arbuckle, John
Washinton, USA
artjuvenation.blogspot.com

Arrowood, Penny
North Carolina, USA
pennylarrowood.blogspot.com

Ashley, David
Colorado, USA
www.davidashleystudio.com

Austin, Rachel
Oregon, USA
www.rachelannaustin.com

Barba, Gwen
California, USA
www.concartastudio.com

Bassow, Sarah
Colorado, USA

Beube, Doug
New York, USA
www.dougbeube.com

Brewster, Claire
London, United Kingdom
www.clairebrewster.com

Cabeen, Lou
Washinton, USA

Clark, Peter
London, United Kingdom
www.peterclarkcollage.com

Collins, Liz
California, USA
www.lizcollinsart.com

Coward, Amelia
Canterbury, UK
www.bombus.co.uk

Cruz, Julia
California, USA

Cusick, Matthew
Texas, USA
www.mattcusick.com

Dettmer, Brian
New York, USA
www.briandettmer.com

Diehn, Gwen
North Carolina, USA
werpiecework.blogspot.com

Dilnot, John
East Sussex, UK
www.johndilnot.com

Duffy, Elizabeth
Rhode Island, USA
www.elizabethduffy.net

Erlich, Sharon
Pennsylvania, USA
"Map Artistry" on Etsy

Evans, Faith
Colorado, USA

Fingal, Jamie
California, USA
www.jamiefingaldesigns.com

Garret, Terry
Minnesota, USA
whisperwoodartworks.blogspot.com

Gracie, Salyna
Washington, USA
www.salynagracie.com

Gradisher, Mary Ann
Indiana, USA

Hamman, Liz
Cheshire, UK
lizhamman.tumblr.com

Hampton, Deedee
Colorado, USA
www.deedeehampton.com

Hardikar, Ram
Göteborg, Sweden
"Manucrafts" on Etsy

Johnson, Emma
Suffolk, UK
emmaporium.wordpress.com

Kasstle, Brian
California, USA
apaperbear.wordpress.com

Kenny, Chris
London, UK
www.englandgallery.com

Kozloff, Joyce
New York, USA
www.joycekozloff.net

LaBadia, Thomas
Florida, USA
www.flickr.com/photos/thomasoo

Leaders, Cindy
Georgia, USA
www.freerangebookbinding.com

Lecourt, Elisabeth
London, UK
www.elisabethlecourt.com

Lucero, Rosalba
Colorado, USA

Machado, Joao
www.villamandacaia.com.br

Margolis, Karen
New York, USA
www.karenmargolisart.com

May, Maude
Oregon, USA
www.maudemakesart.com

Middleton, Lisa
Montana, USA
www.greatriverarts.com

Nasser, Mary C.
Missouri, USA
www.marycnasser.com

Nugent, Rae Kim
Wisconsin, USA
kimraenugent.blogspot.com

O'Neill, Martin
Sussex, UK
www.cutitout.co.uk

Patrick, Jane
Colorado, USA
www.schachtspindle.com

Rankin, Shannon
Maine, USA
www.shannonrankin.com

Riley, Rebecca
New York, USA
www.rebeccarileyart.com

Rombaldi Seppey, Viviane
New York, USA
www.vivianerombaldi.com

St. John, Scott "Tofu"
California, USA
www.tofuart.com

Strand, Julia
Minnesota, USA
www.juliastrand.com

Trout, Diana
Pennsylvania, USA
dianatrout.typepad.com

Vieubled, Benoît
Orléans, France
www.benoit-vieubled.com

ABOUT THE AUTHOR

Jill K. Berry is an artist and author living in the foothills of the Rocky Mountains. She has been crazy for maps for as long as she can remember and teaches mapmaking and map love worldwide. This is her third book about maps and she has ideas for lots more.

ACKNOWLEDGMENTS

I am so very grateful for the team at Rockport that has brought this book to life. This year I had a medical emergency that surprised us all, and despite the delays and struggles I had, this team not only held me up with encouraging phone messages and emails, but also took care of all the details so beautifully.

Thank you to Mary Ann Hall for bringing me into the fold. Thank you to my kind editor Judith Cressy, whose ideas created this book and who was such a good partner, and to Renae Haines, who keeps all of us so splendidly in order and is such a pleasure to work with. More thanks go to art director David Martinell, designer Samantha J. Bednarek, marketing manager Becky Gissel, copyeditor Karen Levy, and proofreader Brian Bertoldo.

Many thanks to the generous and talented contributors that said "yes" to adorning these pages with the beauty of their cartographic creations. Thank you, all of you from around this glorious globe.

INDEX